CLASSIC
SKETCHBOOK
CATS

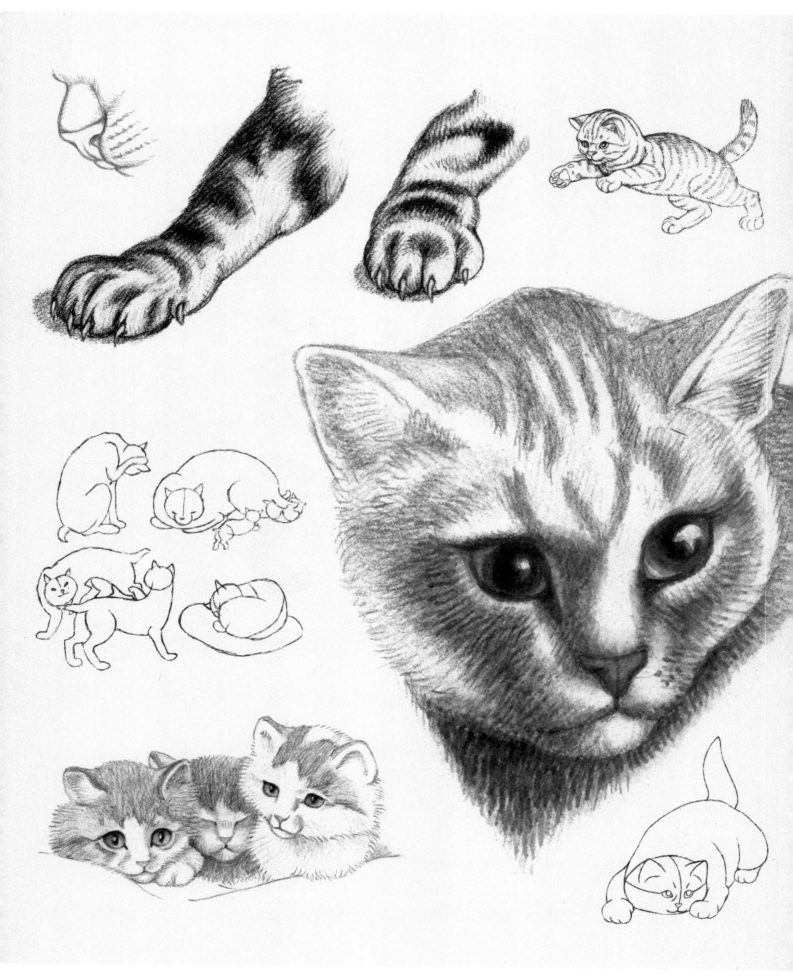

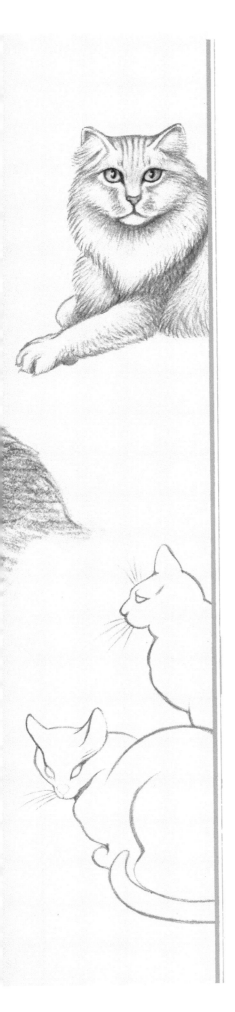
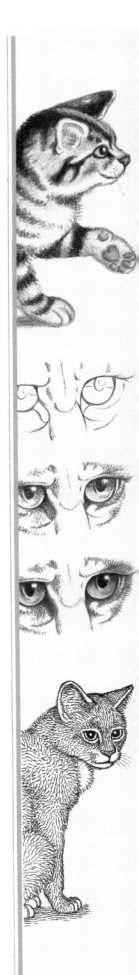

CLASSIC
SKETCHBOOK

CATS

SECRETS OF
OBSERVATIONAL
DRAWING

• • PATRICIA J. WYNNE • •

ROCKPORT

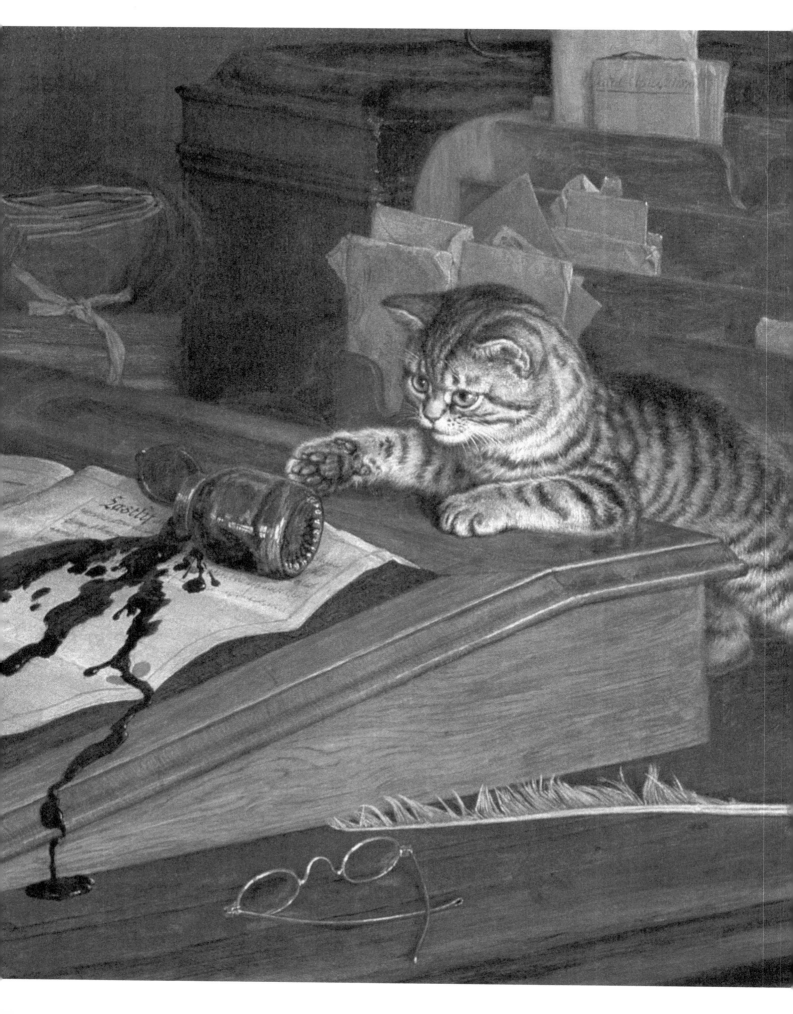

CONTENTS

Witness My Act and Deed,
1882, oil on canvas, Frank
Paton, English, 1856–1909 /
Private Collection / Bourne
Gallery, Reigate, Surrey /
Bridgeman Images

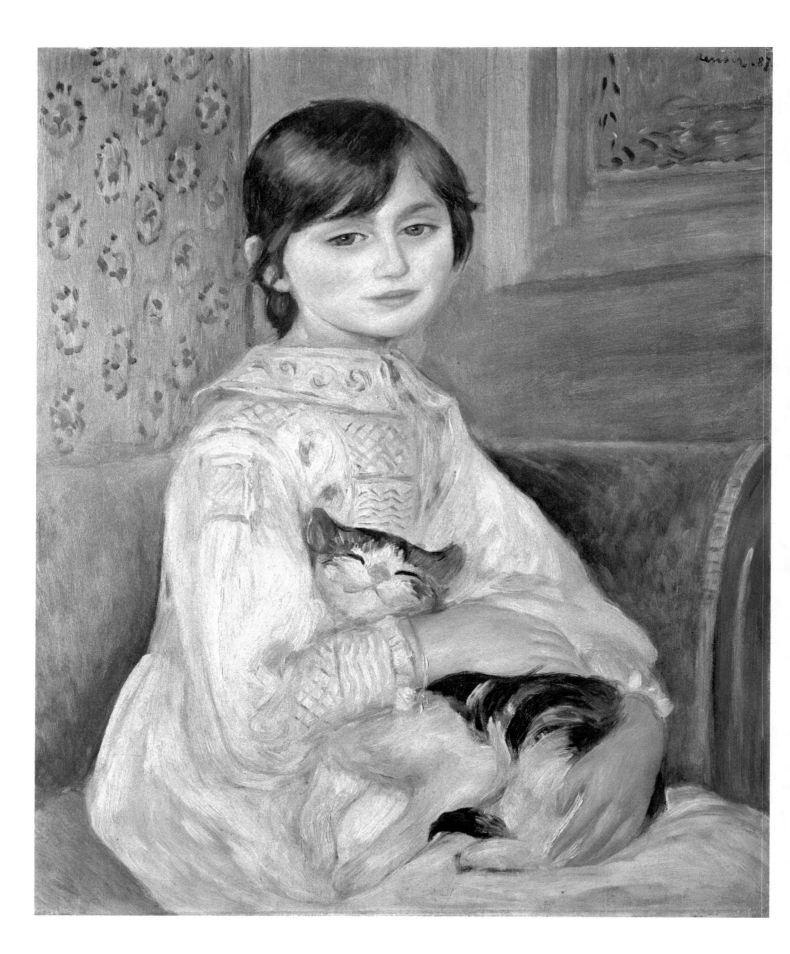

INTRODUCTION

EVER SINCE THE ancient Egyptians domesticated the cat almost 4,000 years ago, its image has appeared in art. Whether pictured under the pharaoh's throne, on the lap of Manet's daughter, in a Kuniyoshi woodblock print, or in a Chardin kitchen scene, the cat is a subject chosen for its beauty and its mystery. Artists, both masters and beginners, bring their personal skills of observation and technique to the goal of portraying this enigmatic creature. Its soft fur, glowing eyes, liquid movements, and bold shape have repeatedly inspired creative people around the world. Assembled in this book are many classic renditions of the domestic cat. It appears elegant, fearsome, sensuous, and silly in renderings by master hands.

..........

Julie Manet with Cat, 1887, oil on canvas, Pierre-Auguste Renoir, French, 1841–1919 / Musee d'Orsay, Paris, France / Bridgeman Images

Almost from the beginning, students have learned by studying the works of the great artists. I went to museums to draw even as a child and am doing so to this day. While teaching at Wayne State University, I sent my students across Woodward Avenue to draw at the incomparable Detroit Institute of Arts because I knew they would profit from the experience.

You are welcomed to an ancient and honorable tradition. By studying the vision, line, and brushwork of the masters, all of us increase our understanding of how art is done. I come from a family who loved felines, all felines, and I have drawn cats my whole life. Inspiration comes from living with creatures at home and visiting them in zoos, from piles and piles of photos, from videos, from taxidermy, and from museum works. Sketching repeatedly from any and all of these sources will improve your work.

Open your sketchbook. I do recommend you use a sketchbook as a repository for your efforts just as the great artists of the past used sketchbooks to familiarize themselves with their subjects. By collecting your drawings in one place, they will be easily located while you build your knowledge of every aspect of the cat form. In the following pages, projects are arranged by cat anatomy, surface appearance, and behavior, which the featured artists observed and which we will be exploring together as well. You can do your sketches in any sequence. Pick your favorites, start there, and develop. The medium is also flexible. I have selected those supplies that I believe work for the projects, but use any material you like. Each subject has step-by-step suggestions for achieving a specific goal. Most importantly, study the images. Drawing is first and foremost an act of observation.

Now, let's get started.

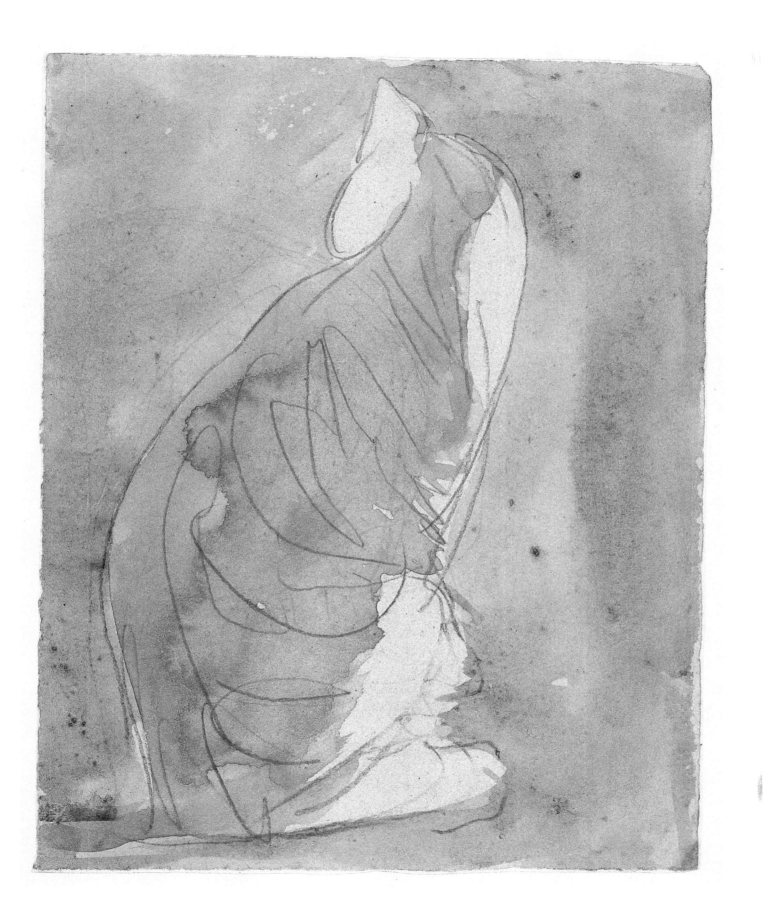

TOOLS AND MATERIALS

AN ARTIST'S TOOLBOX is very personal. It evolves over many years and speaks eloquently about what kind of person has done the work. In any gathering of artists, the first conversation you're apt to hear is "What paper do you use? What pencil is that? Have you tried the latest brush (or pen, or eraser)?" It's the sort of shoptalk that we all love. I have learned volumes from my fellow artists, but I'm still very resistant to insisting that anyone must use my tool choices. So, if you have your favorites, use them. My preferred materials are listed here, as suggestions.

PENCILS

The basic tool of every artist is the pencil. Pencils range in hardness from HB (the same as a #2 writing pencil) to 9H, which is hard enough to cut paper. Hard pencils can build up very subtle variations of gray and draw very crisp lines. The B series builds up lustrous blacks. The softest and blackest is 8B—warning! It smears. Mechanical pencils are very popular and do not require sharpening. I use three pencils: a Dixon Ticonderoga #2 (HB) because it erases and traces well; a Berol Verithin black VT747 because it gives a sharp black line and doesn't smear (or erase); and a Col-Erase gray because it disappears into my drawing and, if not, it erases.

COLORED PENCILS

Colored pencils are the perfect sketchbook tools. They layer and blend so that a few pencils can yield many colors. It is not necessary, however delightful, to own the box of ninety-six colors. Buy a small set and augment it with individual colors that are useful. I recommend three brands interchangeably: Prismacolor, Derwent, and Faber-Castell. None of these fade or smear and they each mix well with watercolor and ink line. Blenders are available, but a little rubbing alcohol on a brush or cotton swab costs less and works just as well. Drawbacks are that these pencils require sharpening and are difficult but not impossible to erase.

Col-Erase does just what the name implies; it erases and is thus good for preliminary sketching and color experimentation, but the color is not vivid and doesn't layer as well as Prismacolor or Derwent.

Lastly, water-soluble colored pencils have been improving over the years. Caran d'Ache, Derwent Watercolor, and Derwent Inktense are all good, the last being the most, well . . . intense. Be careful with it. You will need a brush and water or a cartridge brush. Use heavy paper with water-soluble colored pencils, just as you would watercolors, to prevent paper warping.

..........

Study of a Cat, (watercolor and pencil on paper), Gwen John, Welsh (1876–1939) / National Museum of Wales / Bridgeman Images

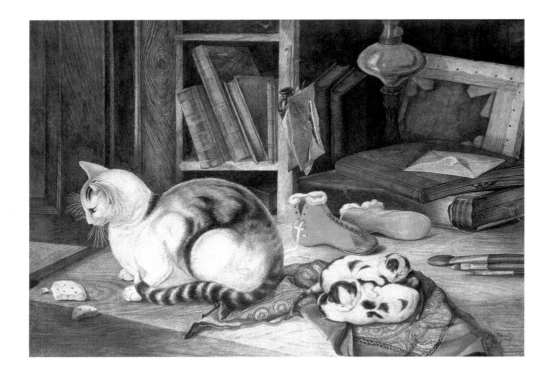

A Happy Family, 1868, watercolor on paper, William A. Donnelly, British, 19th century / Private Collection / Photo © Bonhams, London / Bridgeman Images

ERASERS

Every artist has favorite erasers and a kneaded eraser is on everyone's list. Have a clean, pliable new one to start. I use a Pink Pearl eraser as well. It is aggressive enough to get out even dark pencil lines. My trade secret for removing colored pencil and black ink lines is the Faber-Castell Perfection 7058B eraser stick. It looks like a pencil with a blue brush on one end. If your paper is strong enough, it will get out anything, including micro marker lines. I take it to the art supply store and try it on paper samples just to be sure. Take a pass on electric erasers. They are too energetic to be useful in detailed work.

PENCIL SHARPENERS

A good sharpener is very hard to find and harder to keep. Razor blades and sandpaper never break but few people like them. Small plastic sharpeners may start well but stop working soon. Battery-operated sharpeners don't make sharp points and are not environmentally friendly. I recently hosted an artist who had a lightweight hand-cranked pencil sharpener: Dahle Professional Pencil Sharpener. It is a dream come true at a reasonable price.

INK PENS

Ink lines are not only beautiful alone but also marry well with other media, such as watercolor and colored pencil. My students and many colleagues swear by Micron Archival ink markers. They come in many colors and line thicknesses. The thin ones are #01, #02, and #05. Their lines are consistent and do not smear or bleed. No ink bottle is required, unlike the reliable crow quill pen. Crow quills and other steel nibs are still available and make lines of varying width. I use the somewhat difficult to find Rotring Rapidograph 0.13 mm. It is my favorite drawing tool (I include a sample on page 108).

WATERCOLORS

I've used watercolor frequently in this book alone or combined with colored pencil or ink. Pan watercolors last a long time and are available in small convenient sets of twelve to thirty-six colors. Winsor & Newton makes little sets that come with a brush, sponge, and water bottle. Learn to mix colors. Cats come in shades of brown, black, sienna, and ochre, so you could get individual tubes of those. Used with a cartridge brush loaded with water, pan watercolors are virtually mess free. All you need is a paper towel. Keep an opaque white gouache in your supply box for whiskers and to mix with color for highlights.

BRUSHES

Small brushes are good for painting fur in little strokes. A brush number 0000 makes lashes, tiny highlights, and the veins in the eyes. Number 00 is a utilitarian brush for fur. Numbers 2 and 3 are used for shading and washing over larger areas. I suggest synthetic brushes because small sizes wear out very quickly. Wet your brush tips into a point at the end of each painting session and let them dry that way. Store them upright.

Relatively new is the cartridge brush, which is available in many sizes. Filled with water, it can be used with pan watercolors and water-soluble pencils. Between colors, the nylon bristles wipe completely clean. I highly recommended it.

SKETCHBOOKS AND PAPER

Of all the supplies listed here, the one that may stay with you for a lifetime is the sketchbook. Go to an art store, hold the sketchbooks, and feel the size and the weight. It is not an exaggeration to say that you need to fall in love with the one you buy. After all, you will be spending a lot of time together. Hot press paper has a smooth surface that is excellent for all the materials discussed here. Both Strathmore and Moleskin make bound sketchbooks with smooth, sturdy paper. Sewn-bound sketchbooks are more durable than ring-bound ones. Heavier paper allows for reworking and supports wet mediums like watercolor and water-soluble pencils. Always feel the paper—don't buy a paper you cannot touch. Book artisans at craft fairs often sell beautiful handmade blank books. Take your time. This is important.

If you can't wait to get started, I recommend Arches Aquarelle Grain Satiné, hot press watercolor block 9" × 12" (23 × 30 cm).

Two Studies of a Cat, graphite on discolored wove paper, Théophile Alexandre Steinlen, Swiss, 1859–1923 / Ashmolean Museum, University of Oxford / Bridgeman Images

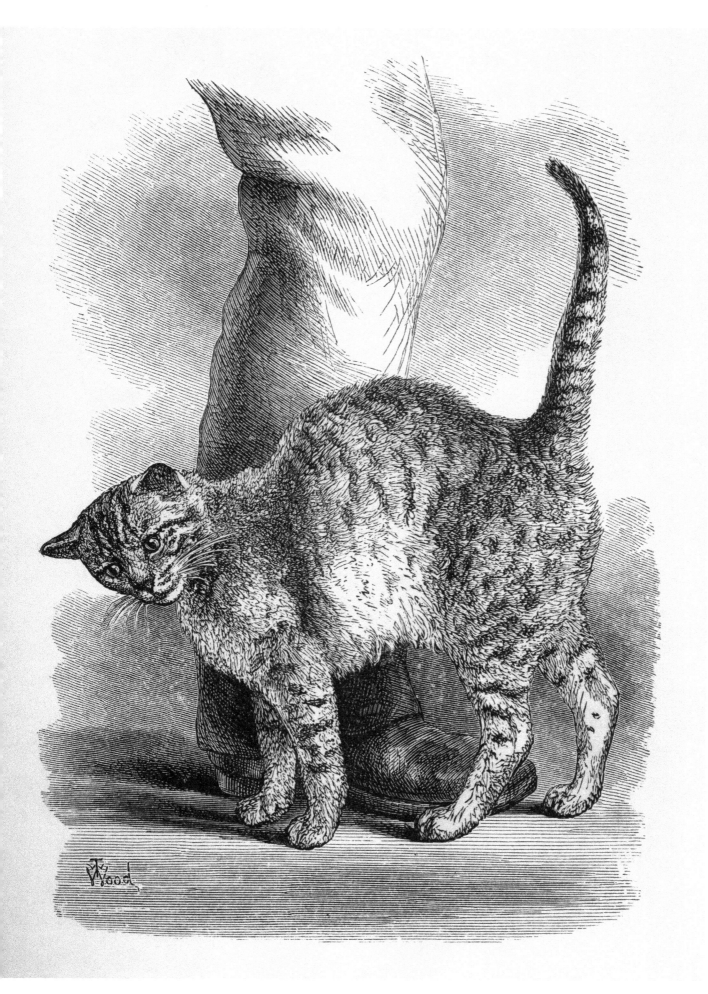

CAT BASICS

Before starting, let's take a moment to look over our subject. Notice the big eyes taking up so much of the cat's face, the triangular nose, pointed ears, and erect whiskers. The head is the focal point of the cat. It is expressive with a happy, curving smile. An elegant sweeping line follows the spine from the neck to the tip of its eloquent upright tail. Look inside.

Supporting bones and strong muscles shape the cat's body and legs and define the cat's proportions and poses. Neat, round little paws and soft fur finish the picture. Think of our cat as a visual table of contents guiding you to pages of information on each subject.

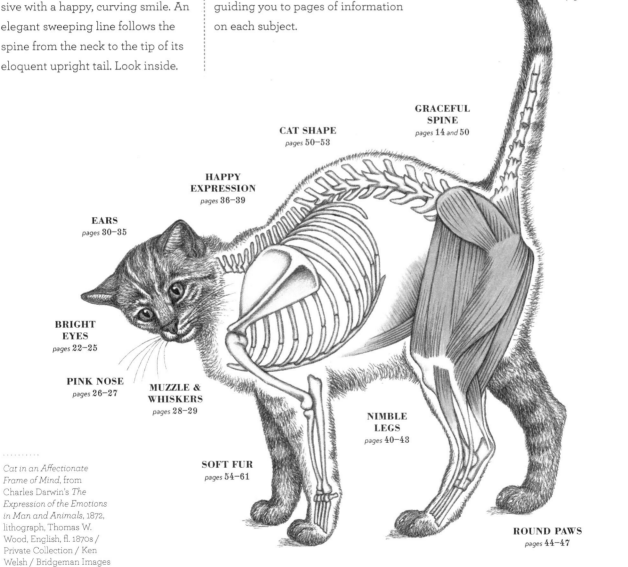

TAIL OF CONTENTMENT
pages **48–49**

GRACEFUL SPINE
pages **14** *and* **50**

CAT SHAPE
pages **50–53**

HAPPY EXPRESSION
pages **36–39**

EARS
pages **30–35**

BRIGHT EYES
pages **22–25**

PINK NOSE
pages **26–27**

MUZZLE & WHISKERS
pages **28–29**

NIMBLE LEGS
pages **40–43**

SOFT FUR
pages **54–61**

ROUND PAWS
pages **44–47**

Cat in an Affectionate Frame of Mind, from Charles Darwin's *The Expression of the Emotions in Man and Animals*, 1872, lithograph, Thomas W. Wood, English, fl. 1870s / Private Collection / Ken Welsh / Bridgeman Images

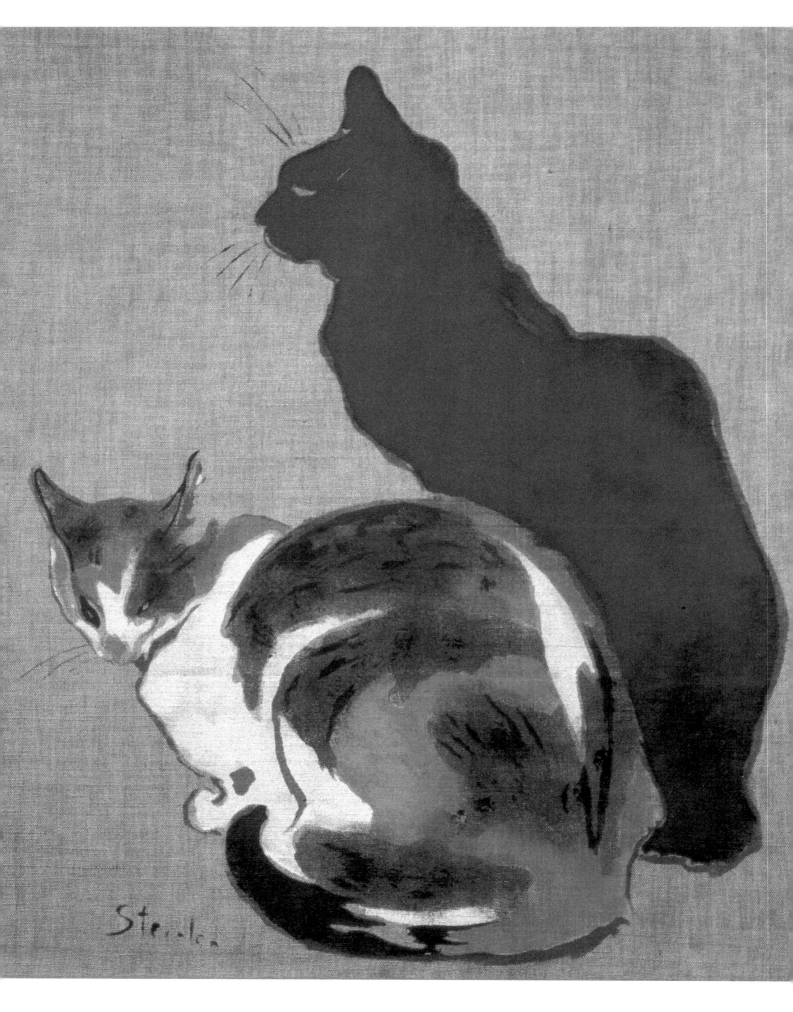

THE GRACEFUL POSE

No animal moves its body into more liquid, graceful poses than a cat. The oval head, curved line of the spine, and sweeping tail are beautiful even at rest, as the sitting and crouching cats in this painting exemplify. A quick, simple line gesture from this work is completely satisfying as it is. But let's see what else we can discover.

1. Quickly draw the cats' outlines using the curves of their faces, backs, and tails as a focus. The gesture alone is beautiful. (See A.)
2. Notice the cats in the painting have a gray line around them. Refine your outline and darken it. Use colored pencil to make an interesting gray. (See B.)
3. With colored pencil, lightly explore the use of orange and brown shapes to emphasize the calico cat's curves. (See C.)
4. Add black to the brown patches. It suggests fur. The sitting cat is a bold, flat shape. (See D.)
5. I enhanced the orange using watercolor and chose an indigo blue wash to make the black sections richer. (See E.)

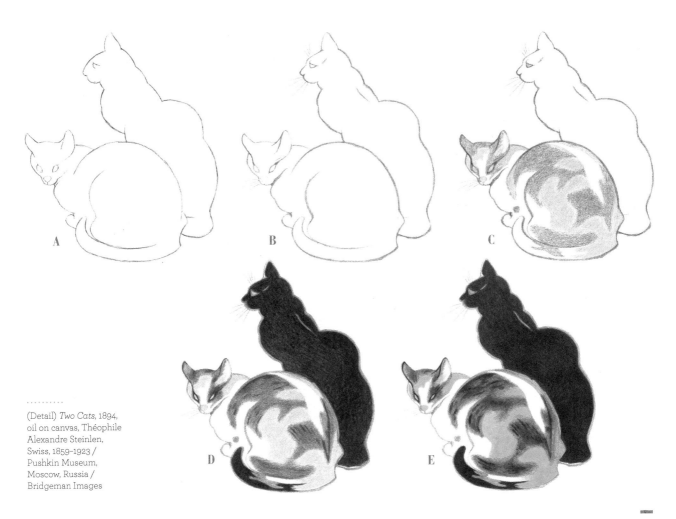

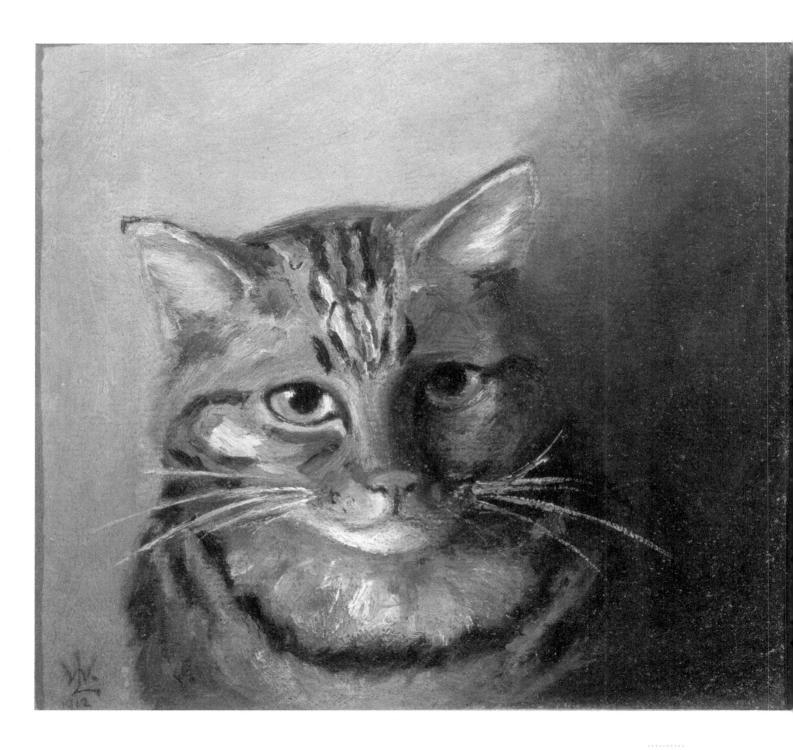

A Head Study of a
Tabby Cat, Louis Wain,
English, 1860-1939
/ Private Collection
/ Photo © Bonhams,
London, UK /
Bridgeman Images

FACE VIEW

The cat facing forward is the view we all learn to draw first. I picked this example because the cat's expression is bemused and interested. But I also found it interesting because the artist used a palette containing colors not often associated with mammals of any kind—least of all cats. It is not a detailed work but it has everything that is needed to make an engaging feline portrait: focus, expression, good contrast, and personality.

1. The circle divided into four parts is a classic model for heads of all sorts and is particularly well suited to a cat face. The lining up of the ear, eye, and nose is useful. Using the circle (tilted for this pose), sketch in the features of the cat's face. (See A.)

2. Continue with pencil, adding details such as the pupils, shapes of the eyes, ears, and nose, and the direction and pattern of the fur. (See B.)

3. A gray-black watercolor on a small brush is excellent for adding weight to the line drawing. Continue to make the lines in the direction of the fur. I was amazed to see so much blue-green in the reference painting. It is my favorite color and I added it early. (See C.)

4. Look at the colors I found! Salmon pink, earth green, terracotta, lemon yellow, and more blue-green. In colored pencil, explore the possibilities of using these colors for your cat. (See D.)

5. I used light washes of color over my pencil selections. Sometimes you just have to have faith that the drawing will work. (See E.)

6. Lastly, use black and brown watercolor to make tonality and contrast. (See F.)

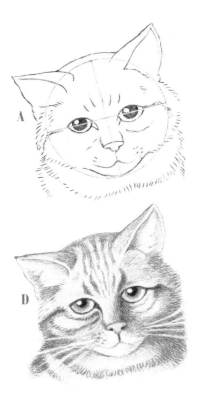

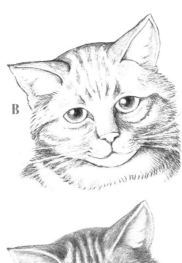

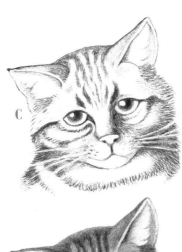

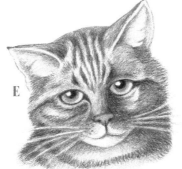

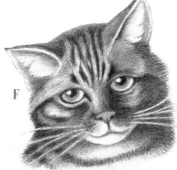

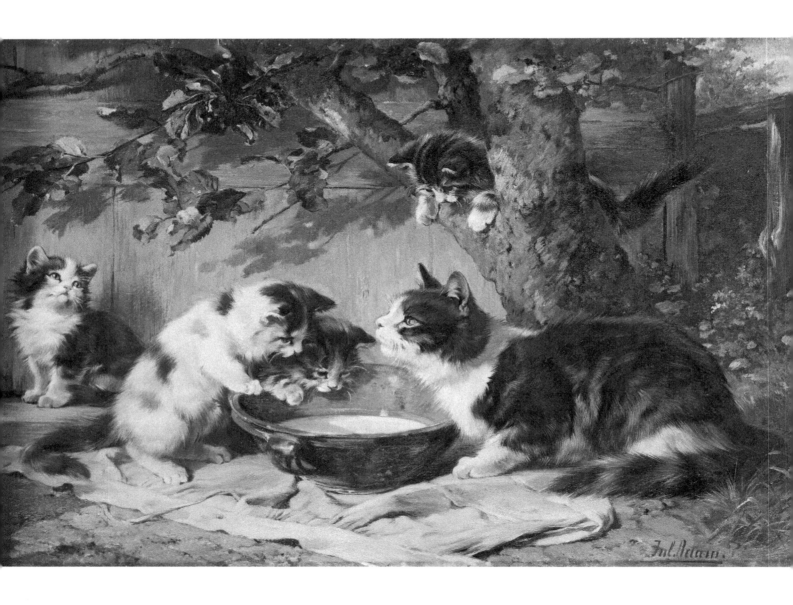

SIDE VIEW

The shape of a cat's facial profile ranges from the sloping nose of an Egyptian bronze figure to the short, flat face of the Persian. The cat in this painting is comfortably in the middle. It has long fur, which we'll look at later in this book, but here the purpose is to become comfortable drawing the side view of the head. After finishing this one, you might want to try some other profiles in your sketchbook for comparison.

1. Using the circle and arrow as a general guide, sketch the basic features of the cat's profile in pencil. (See A and B.)
2. Add detail with pencil. The direction and tonal variation of the fur is important. Leave the white areas empty for now. (See C.)
3. Using colored pencil, explore the color range of the subject. Don't be afraid to use un-catlike colors.

I put lavender in the shadowed white fur. The eye is fun to finish at this point. (See D.)
4. A watercolor wash of browns, pinks, lavenders, and yellows will provide the highlights for the next stage. (See E.)
5. Finish the sketch by adding black watercolor and pencil. Stroke your brush in the direction of the fur. When the paint is dry, add any little touches you choose. (See F.)

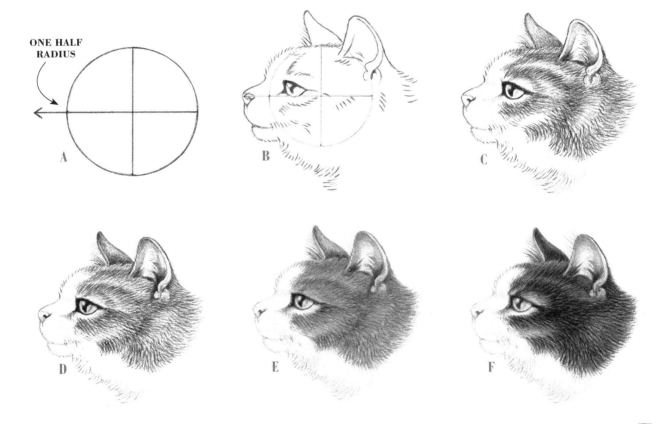

ONE HALF RADIUS

A

B

C

D

E

F

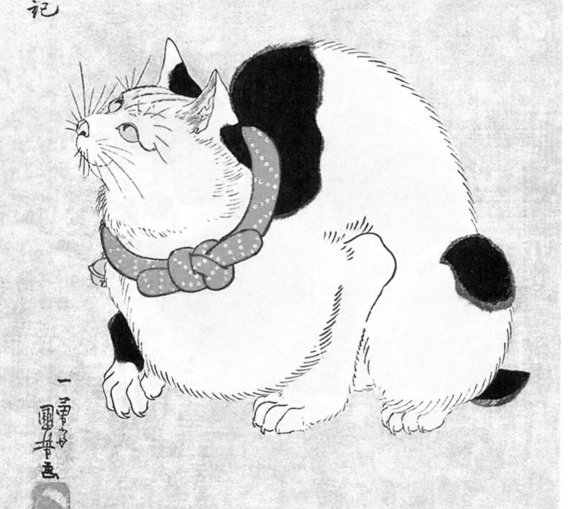

A Japanese Cat,
woodblock print,
Utagawa Kuniyoshi,
Japanese, 1797/8–
1862 / Pictures
from History /
Bridgeman Images

THREE-QUARTER TURN

The Japanese produced hundreds and hundreds of images of the cat, each one charming, fanciful, or frightening. They appear stylized and cartoon-like at first glance, but look again. The turned head pose gives artists the most trouble and yet with just a few lines, Kuniyoshi has accurately conveyed the facial characteristics of his subject. It is a simple, elegant study that you will enjoy just as it is. I used pencil, colored pencil, and a little gray and black watercolor.

1. The circle with bisecting lines will help you place the features of the face. Move the lines to arrive at a guide for different angles. (See A and B.)
2. Using the circle model, rough in a pencil line sketch of the cat's turned head. Tilt the paper or the circle to lift the head. Always turn your paper when working to find a comfortable angle. (See C and D.)
3. Refine and darken the lines of the cat. I used yellow pencil in two shades for the bell and eyes. The dots are Verithin pencil in peach. (See E.)
4. Paint neutral tint watercolor over all the gray lines. Neutral tint blends well with all colors and is a very useful pigment. Two yellows colored the eyes. (See F.)
5. This is a quick cat. Black paint makes the pupils and ear spots dramatic. Two colored pencils finished the collar. (See G.)
6. Soft peachy toned spots of colored pencil are all that is left to finish this work. So charming. (See H.)

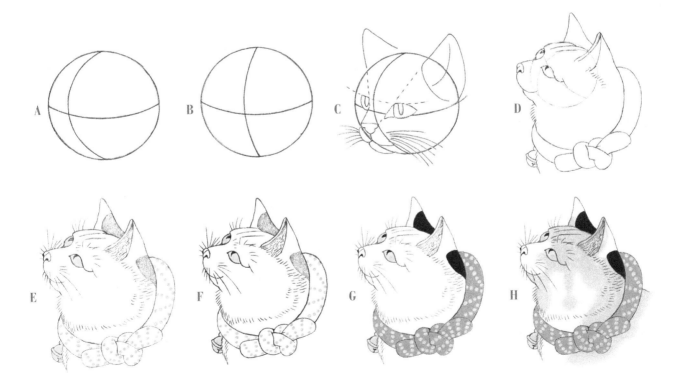

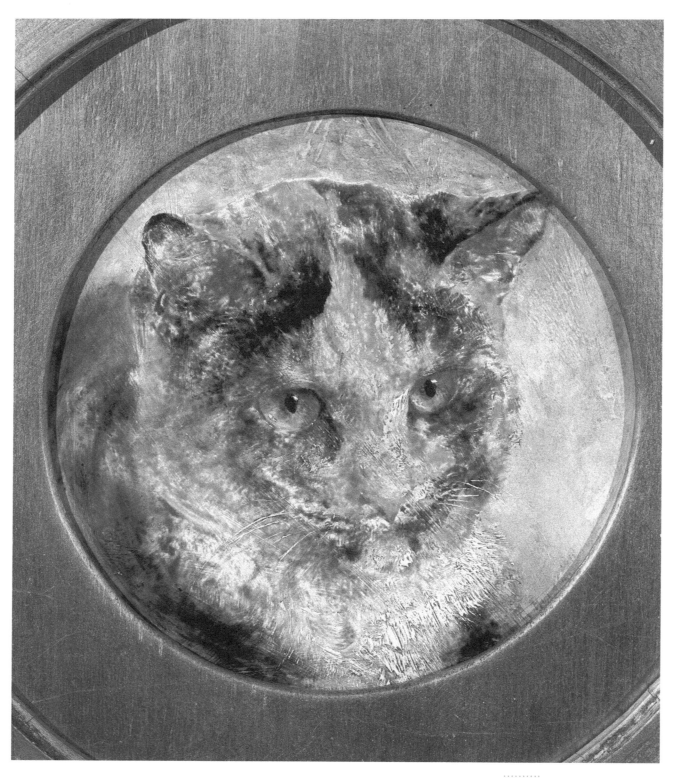

Study of a Tortoiseshell Cat, oil on board,
William Huggins, British, 1820–1884 / Private
Collection / © Arthur Ackermann Ltd.,
London / Bridgeman Images

EYES FROM ALL ANGLES 1

bright light ← darkness

The pupil adjusts to let in more or less light. At night it is almost a circle. In bright daylight or when you use the flash from your camera, it becomes a slit.

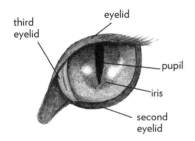

eyelid
third eyelid
pupil
iris
second eyelid

A knowledge of anatomy will always improve drawings. Note that the cat has three eyelids and its iris is not as distinct as ours.

This brushy portrait of a tortoise-shell cat has arresting, deep eyes. The artist shows the shadow cast by the upper eyelid and makes the eyes come alive with the use of a white highlight. Most marvelous and challenging for me is the way the pupil appears to float above the iris in a cat's eye. The pupil is actually an adjustable hole in the iris but its appearance of floating lends a beautiful and mysterious touch.

1. Lightly outline the basic shapes in pencil. You won't need to erase this sketch, so try it with a black colored pencil. (See A.)
2. Add pencil to indicate the dark areas and the direction of the fur. Look for the little specks of dark on the iris and the cast shadow of the eyelid. (See B.)
3. Purple and violet in a cat! Wonderful. I added detail with purple colored pencil everywhere I saw it in the painting. (See C.)
4. I layered yellow-ochre and sienna watercolor to the eyes. Start with the little details, then wash over the whole eye with bright amber. I left the highlight unpainted. Some artists use a mask to shield the highlight or add an opaque white for the highlight at the end. (See D.)
5. Use a terra-cotta colored pencil to stroke in the orangey fur texture. Follow up with light orange and yellow watercolor in the same areas. (See E.)
6. Darken any accents with watercolor or colored pencil. Be sure the pupil is lustrous black, the highlight bright—then you're done. (See F.)

A
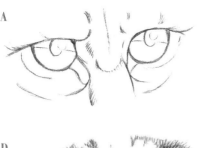

B
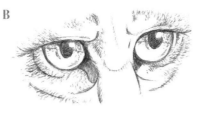

C
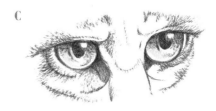

D
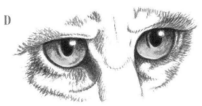

E
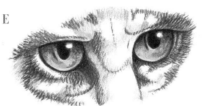

F
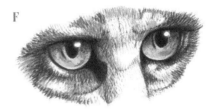

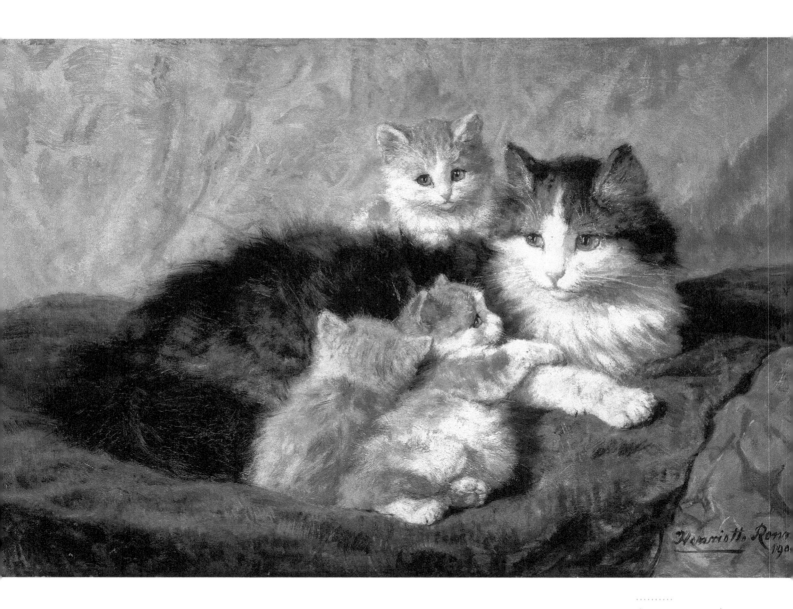

EYES FROM ALL ANGLES 2

Study the two middle kittens of this family portrait. The most meticulous detail work has been reserved for the eyes. The young cats' blue eyes are shown deeply set in white and orange fur. One has a concerned expression emphasized by its markings, and double highlights bordering the pupils. Both have a little sliver of orange reflection in their eyes.

1. Make a light sketch of both kittens' eyes. Decide on the location of the highlight. Note the little margin of skin at the back of the side eye. (See A.)

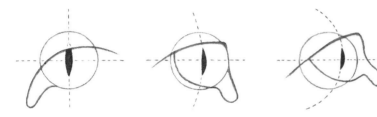

The eyeball for most mammals is round. It's the shape of the eyelids that gives it the appearance of being ovoid, lozenge-, or wedge-shaped. Using a circle and a dashed line midway through the pupil, the artist can turn the eye in a sketch to any orientation.

2. Using colored pencil, stroke in the fur direction. Within the eye, indicate any color variation and texture you see or want. I used indigo blue lines radiating from the center to form the iris even though they are not in the painting.

 Add more color strokes. Because these are warm-colored cats, try using yellow and salmon pink to shade the white areas. (See B.)

3. Add watercolor, stroke fur, and layer color over the eyes. The darker blue with soft edges went down first to indicate the iris, then a paler blue for the whole eye. (See C.)

4. Wash watercolor over broad areas until you achieve a look you like. It never hurts to add another layer of color to the eyes. (See D.)

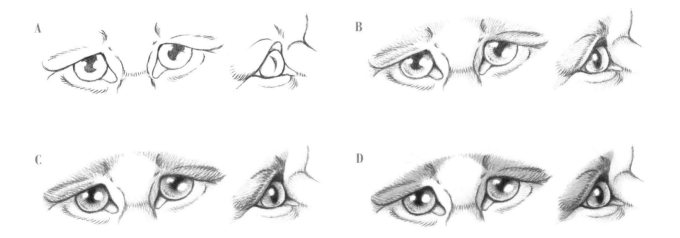

A B

C D

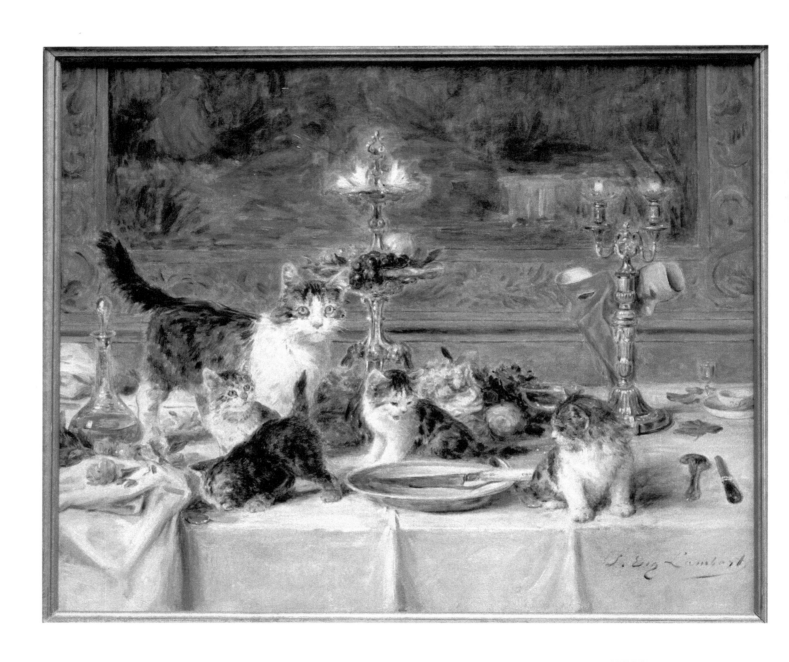

After Dinner Guests, oil
on board, Louis Eugene
Lambert, French, 1825–1900
/ Private Collection /
Photo © Christie's Images /
Bridgeman Images

NOSES

The domestic cat's nose comes in a surprising variety of colors but in general, the shape and location are consistent. In this work, there is a pink nose, a brown, a gray, and one with dark patches. Each of the noses has white fur around it, giving the subjects a particularly delicate look while they are up to some serious mischief.

1. Lightly sketch noses in different positions. Think of the nose as a triangle pinched into a T and pushed down a little at the top. (See A.)

2. Add shading to shape the nostrils, spots in four rows for whisker follicles, and hair strokes. All the fur around the nose is short so use small pencil strokes. (See B.)

3. The area around our subjects' noses is white so just add a little color for shading and interest. I used yellow and lavender. The skin of the nose is not smooth but finely pebbled. I stippled them with a pink pencil for texture. (See C.)

4. For the white fur, use very pale modeling strokes in the shaded areas. The follicles are darker. Paint the noses in different colors and add whiskers with pencil. I added a black edging for the first nose. My cats have this feature. (See D.)

HINT › It always helps to look at your drawing from a distance. Prop it up across the room so that you see it quite by surprise. I always understand my work better when I do this.

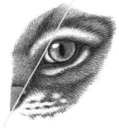

The edge of the nostril aligns with the inside corner of the eye on the same side even if the head is seen from different views.

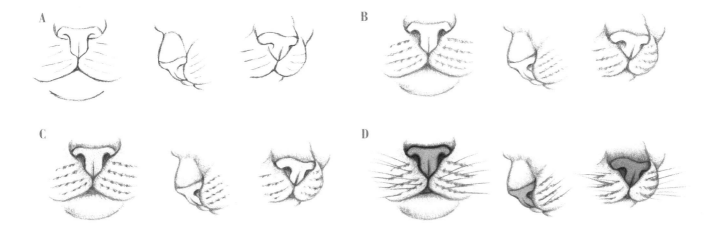

A

B

C

D

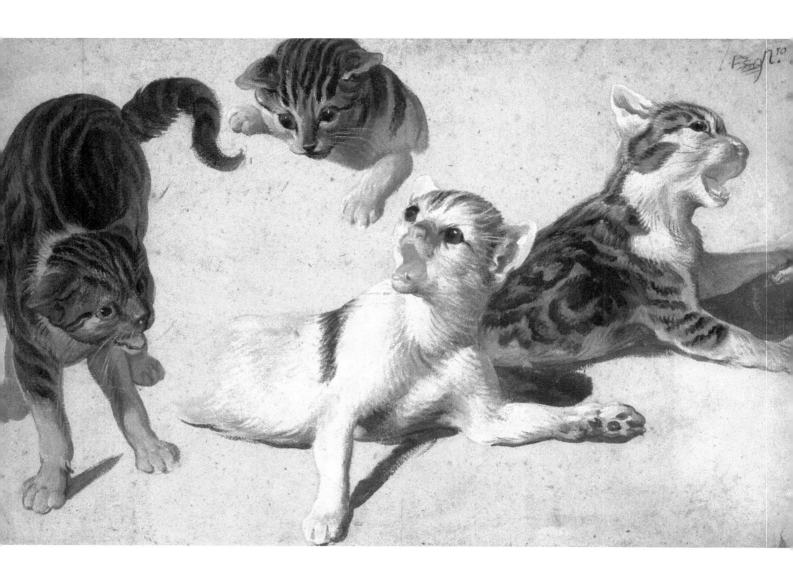

Four Studies of Kittens,
oil on light brown paper,
Alexandre-François
Desportes, French, 1661–1743
/ Private Collection /
Photo © Agnew's, London /
Bridgeman Images

THE MUZZLE: WHISKERS, MOUTH, TEETH, AND TONGUE

Alexander François Desportes was King Louis XVI's painter of the royal hunt and of animals. Desportes did hundreds of life sketches of cats in preparation for his paintings and this oil sketch of kittens is one.

In the skull of an adult domestic cat, the teeth are large and sharp with long canines, or fangs. Desportes's kittens are much younger and still have their baby teeth.

1. Sketch outlines of faces with attention to the muzzle. Locate the teeth with the tongue fitting between. Draw the eyebrow and cheek whiskers and the rows of muzzle whisker follicles. (See A.)

2. Using colored pencil, put down light hues everywhere: White can have myriad colors in its shadows. I added a little yellow to the teeth so they wouldn't be so stark. (See B.)

3. Accent features in colored pencil. The back of the open mouth is shadowed. Make the blacks in the fur and eyes darker. Glaze the white fur colors with a white pencil. Press hard. (See C.)

4. Finish the eyes and stroke in hairs in the coat patterns. Wash coats of pink over the inside of the mouth and nose. (See D.)

5. Add accents such as shadows around the nose and the back of the mouth. Add more black on the pupils. Finish with gray pencil whisker strokes. (See E.)

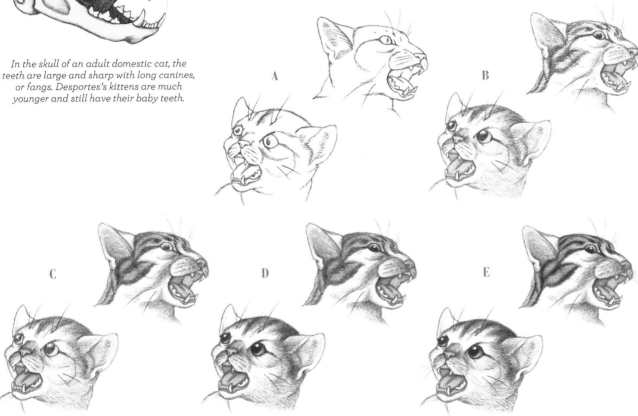

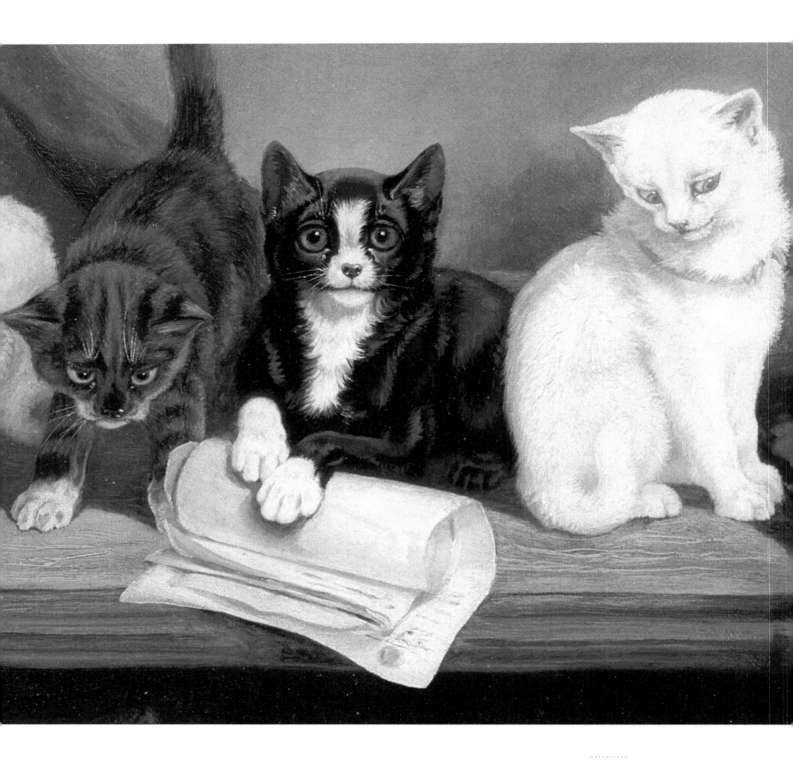

.
This detail and pages 32-33: *Women's
Rights—A Meeting*, 1885, oil on canvas,
William Henry Hamilton Trood,
British 1848-1899 / Private Collection
/ Photo © Bonhams, London, UK /
Bridgeman Images

EARS 1

A cat's ear seems deceptively easy: a pointed triangle on top of the cat's head, right? Well, yes and no. First of all, a cat's ear is rounded at the tip; secondly, it attaches mainly to the side of the head—but it is a triangle.

1. Outline three views of ears. Note the side shelves, long hairs, rounded tops, and of course Henry's Pockets. The tragus is usually covered with fur and doesn't show at all. (See A.)
2. Using black pencil for the first two sets of ears, add little hairs, paying attention to their direction. Use pink to shade the ears of the white cat. (See B.)

3. With a neutral-tint watercolor and a fine brush, deepen the value of the pencil strokes. For the white cat, I used red mixed with a neutral tint and watered it down to pale. (See C.)
4. For the first cat, use a fine brush to stroke in brown hairs. For the middle cat, use blue and gray for the hairs and red for the skin. For the white cat, shade with lavender. (See D.)
5. To finish the first cat's ears, wash in broad coats of brown. Use a different brown for each coat and allow each to dry before the next. For the cat in the middle, layer in broad coats of black, blue, and red. Glaze cat three with a white colored pencil. (See E.)

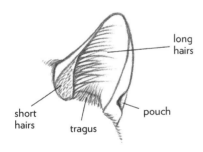

long hairs

short hairs

tragus

pouch

The cat's external ear functions as a funnel with shelf-like structures on both sides and a stiff flap at the bottom that guide sound waves down to the internal ear. Hairs in the ear's opening keep out dirt and flying insects. The little fold and pocket to the outside of each ear is called the cutaneous marginal pouch, or Henry's Pocket.

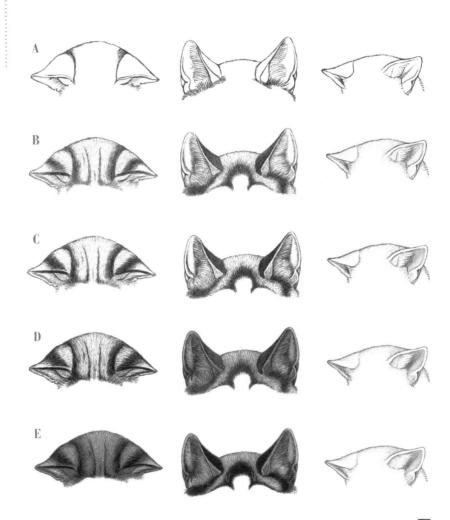

A

B

C

D

E

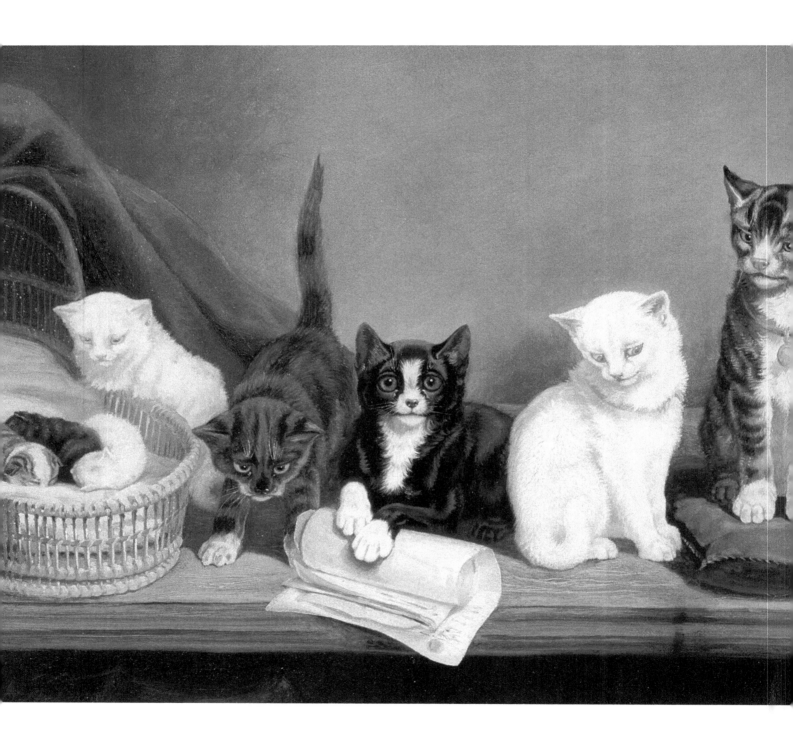

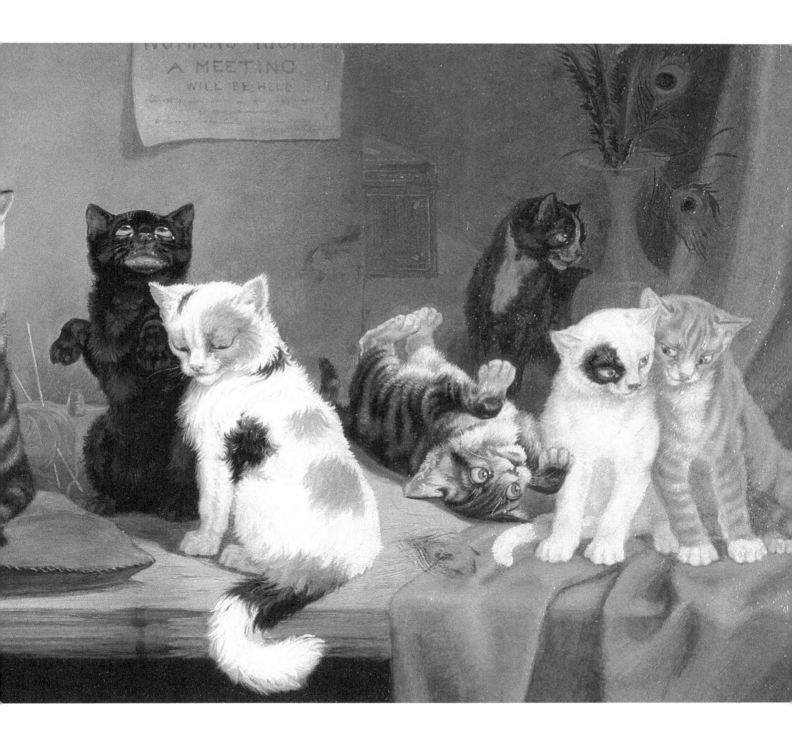

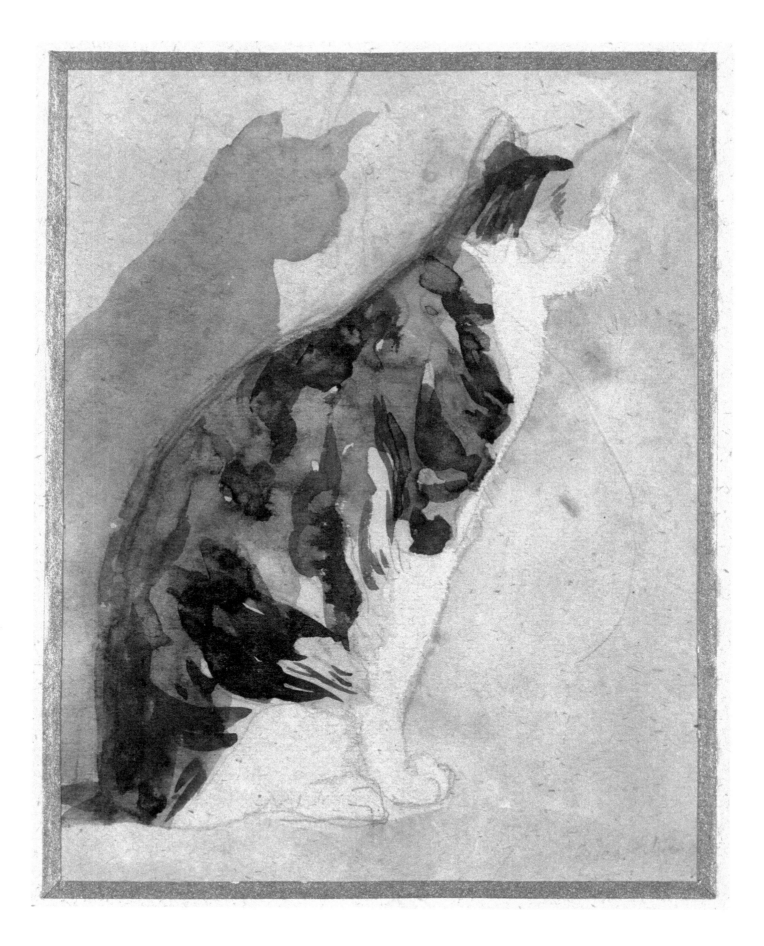

EARS 2

Gwen John's watercolor of her adored tortoiseshell cat is so simple yet completely feline. The cat's ears are pitched forward to hear something we cannot see and they're perfect in outline and minimal form.

Every cat person will recognize this pose: elegant ears on an attentive, intense profile of a concentrating cat. I would have loved drawing the whole form but this exercise is about ears, so let's begin.

1. Start with a line drawing. Include as much detail as you think you might need. (See A.)
2. A delicate colored pencil background will help define the cat's shape, especially the profile. (See B.)
3. I used many pale watercolor overlays of oranges, yellows, and pinks to achieve as much variety as possible. Allowing only some coats to dry before the next overlay added to the serendipity. (See C.)
4. Layer black transparent washes over and over again to achieve a painterly tortoiseshell effect. I left out the whiskers. You might prefer to put them in, perhaps with a stick eraser. (See D.)

 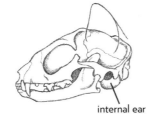 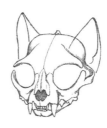

internal ear

The inner ear of a cat is located inside a hollow bulb of bone at the back of the skull. The external ear, the structure we call the ear, is attached to the side and moves around to pick up noise and direct it down to the internal ear.

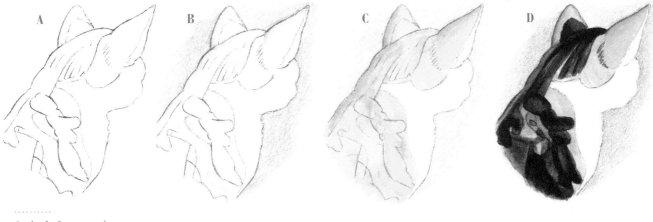

A B C D

Study of a Cat, watercolor on paper, Gwen John, Welsh, 1876–1939 / Private Collection / The Stapleton Collection / Bridgeman Images

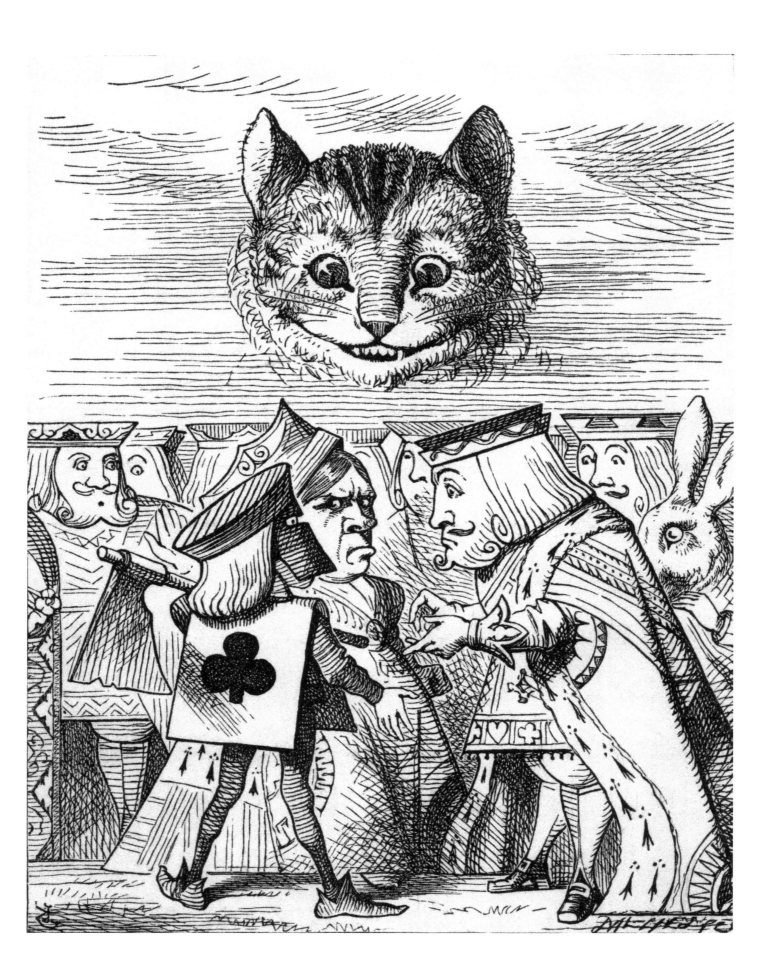

FACIAL EXPRESSIONS 1

John Tenniel's drawings for Lewis Carroll's *Alice's Adventures in Wonderland* are as well-known as the story itself. One of the most famous is the image of the Cheshire cat. Originally drawn in ink and then printed with lithography, this line drawing exudes personality. The face is a hybrid of cat, human, and imagined faces and manages to be at once friendly, frightening, and mischievous. We'll work this drawing solely with pencil and ink.

1. Make a pencil sketch for placing the facial features. Keep the sketch light so that you can erase the lines after you ink them. Notice the menacing un-catlike teeth. (See A.)
2. Draw in ink over the pencil lines. Go back in with your pencil and add more detail to indicate areas of texture. Ink those areas too. (See B.)
3. Now add detail to build up the darker areas. When layering ink, do not work wet into wet: The lines will bleed into each other and become fuzzy. Let one set of ink lines dry thoroughly, then add more. Look how wide the cat's grin is, extending far beyond its eyes. (See C.)
4. Finish the eyes, nose, and grin. Darken the texture from the top down. This is not so important if you are using Micron pens, but it is essential if you are drawing with liquid ink. (See D.)
5. Darken the sides of the face, add accents, and erase the underlying pencil drawing. (See E.)

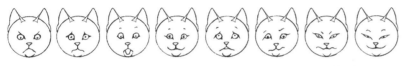

Human expressions applied to a feline face are instantly understood by the viewer.

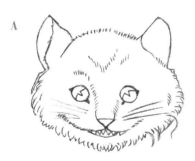
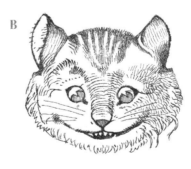
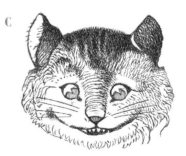
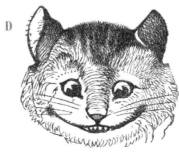
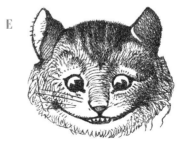

The King of Hearts Arguing with the Executioner, lithograph from *Alice's Adventures in Wonderland* by Lewis Carroll, published 1891. John Tenniel, British, 1820–1914 / Private Collection / Ken Welsh / Bridgeman Images

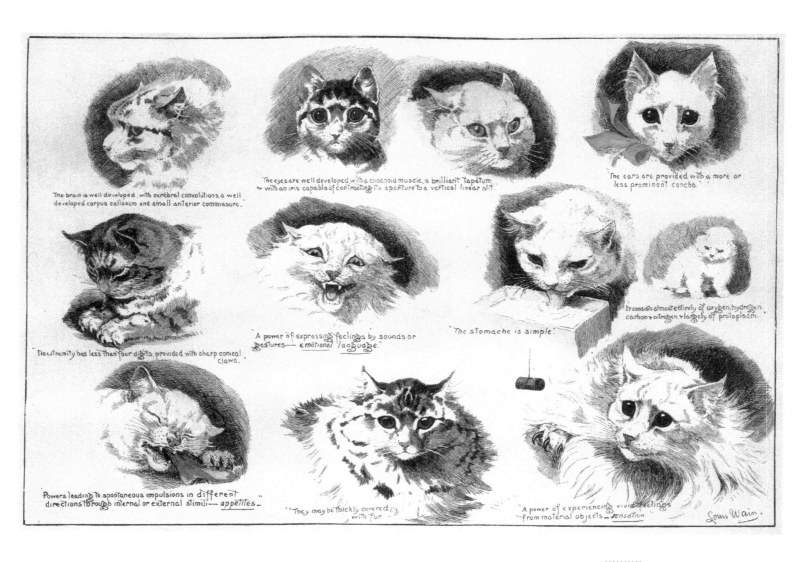

The brain is well developed, with cerebral convolutions, a well developed corpus callosum and small anterior commissure.

The eyes are well developed, with a choanoid muscle, a brilliant tapetum & with an iris capable of contracting its aperture to a vertical linear slit.

The ears are provided with a more or less prominent concha.

No extremity has less than four digits, provided with sharp conical claws.

A power of expressing feelings by sounds or gestures— emotional language.

"The stomache is simple".

It consists almost entirely of oxygen, hydrogen, carbon & nitrogen & largely of protoplasm.

Powers leading to spontaneous impulsions in different directions through internal or external stimili — appetites.

"They may be thickly covered with fur"

"A power of experiencing vivid feelings from material objects — sensation"

Louis Wain.

FACIAL EXPRESSIONS 2

This selection of cat heads offers many choices of expression. I decided on sweet, worried, and irritated.

1. Start with a light, sketchy pencil drawing without much detail. Emphasize the eyes, nose, and mouth line. (See A.)
2. Add light colored pencil. Keep the style open so the eyes, nose, and muzzle are the most dramatic parts of the drawing. (See B.)
3. Now brush light watercolor over the pencilwork. On this piece, an airy delicate feel is what we're looking for. Add darker watercolor to the eyes and just a little to the shadowed areas. (See C.)
4. Finish with a few dark brush strokes to the eyes and some opaque white brushstrokes for whiskers and long ear hairs, and we're done. (See D.)

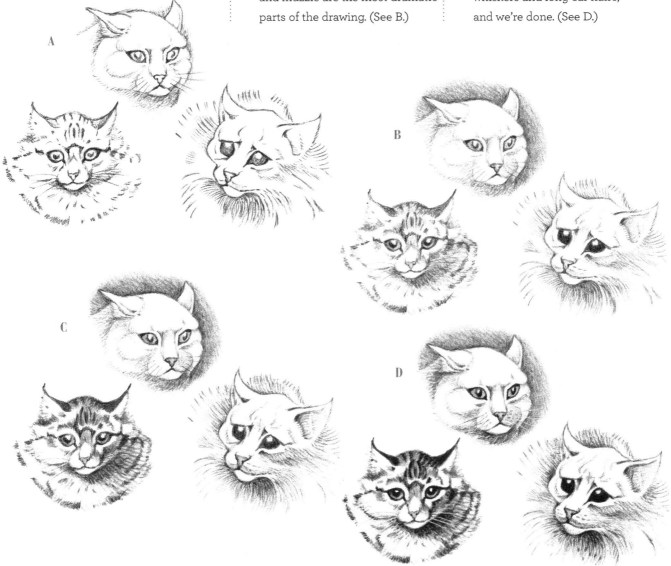

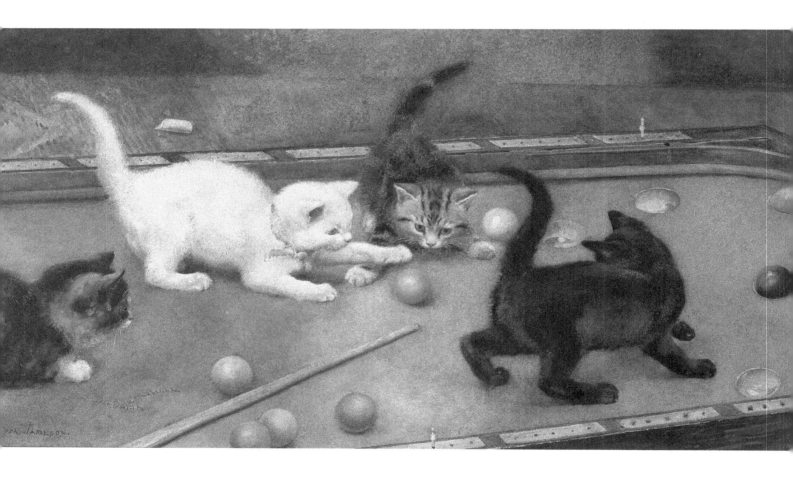

Bar Billiards, watercolor,
Rosa Jameson, English,
fl. 1885–95 / Private
Collection / Photo ©
Chris Beetles Ltd, London /
Bridgeman Images

LEGS 1

In this painting, Rosa Jameson solved a couple of artistic problems at once. The first is how to show anatomical features in an all-white or an all-black cat. The second is foreshortening.

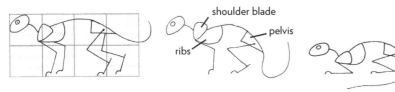

This grid box is a handy tool for determining the leg and body proportions of an adult cat. The simple framework is helpful for placing and bending legs the correct way at the correct joint. Quadruped legs actually do bend as ours do.

1. Make a light framework sketch. Outline the cats lightly and use the framework to place and bend the legs. (See A.)
2. Use the shape of the inner framework to guide your shading of the legs and body. (See B.)
3. Remove the framework as you continue to round the cats' forms. (See C.)
4. Add the watercolor, using a small brush with a neutral tint. Paint very lightly on the white kitten. (See D.)
5. To finish the kittens, I simply added a couple of wash coats of watercolor on the brown and black kittens and just a little extra pigment for the white one. (See E.)

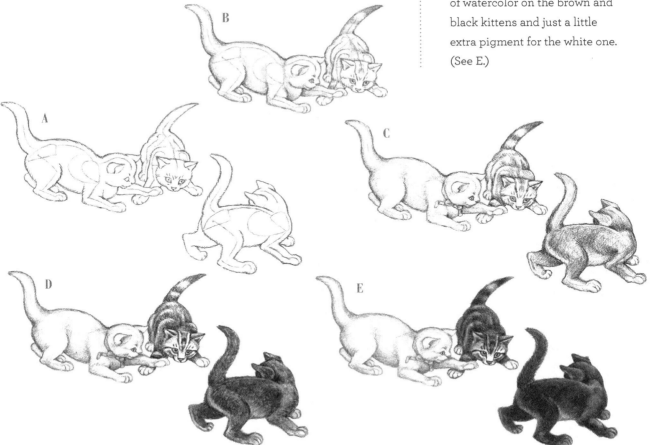

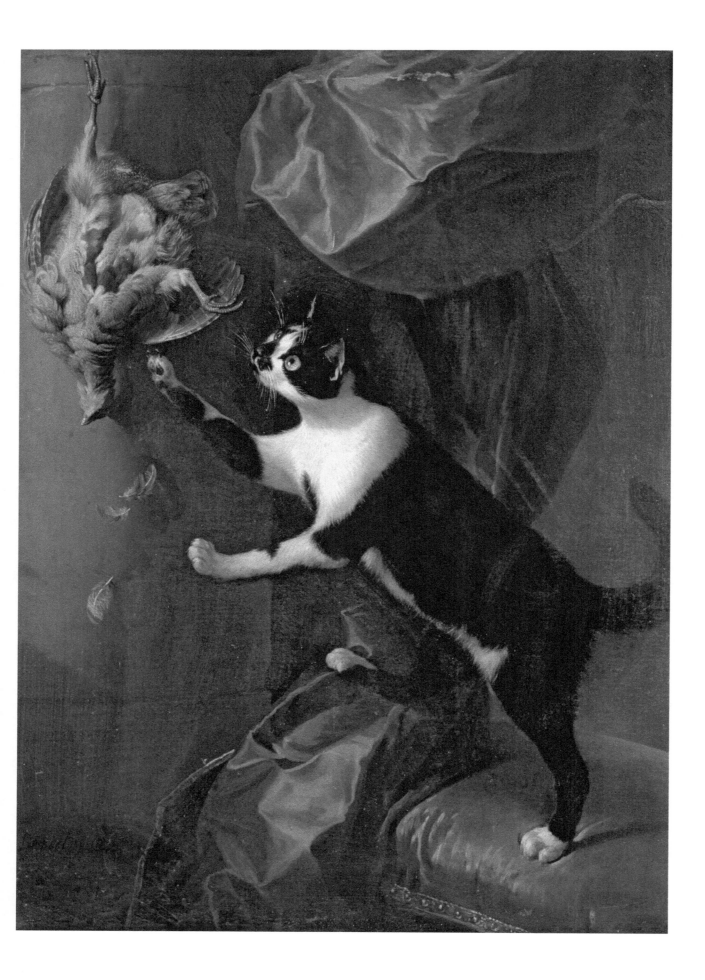

LEGS 2

Alexandre-François Desportes's portrayal of this handsome tuxedo cat is so full of personality it certainly must have been a cat he knew well and observed closely. I chose this painting because of the lovely extended legs of the stretching cat.

1. Make a light framework sketch and then make your drawing around it. (See A.)

Science illustrators draw the skeleton first and overlay muscles and skin to reconstruct an animal. It is a very interesting exercise in discovery.

2. Lightly shade with colored pencil using the framework for a guide. Put whiskers in with a gray pencil, pink in the ears, and yellow in the eyes. (See B.)

3. Erase the framework and darken the shading. I used yellow ochre and pale yellow to shade the white fur. (See C.)

4. Paint two layers of neutral tint over the black areas, pink in the ears, and a little yellow in the white areas. (See D.)

5. Add a few coats of black until the fur is dark enough. Let each coat dry before the next is added. Notice the anatomy is retained even in the black areas. (See E.)

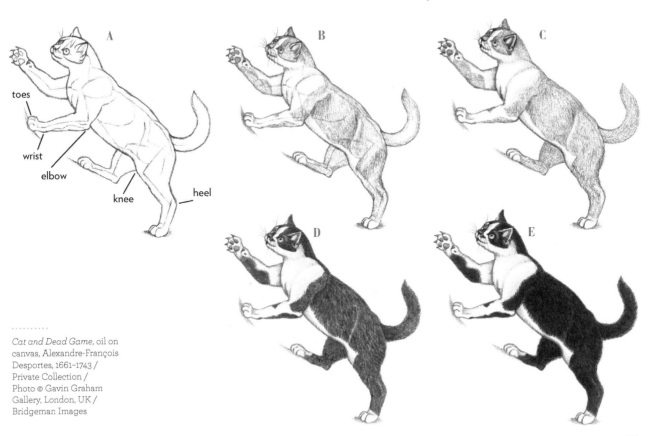

Cat and Dead Game, oil on canvas, Alexandre-François Desportes, 1661–1743 / Private Collection / Photo © Gavin Graham Gallery, London, UK / Bridgeman Images

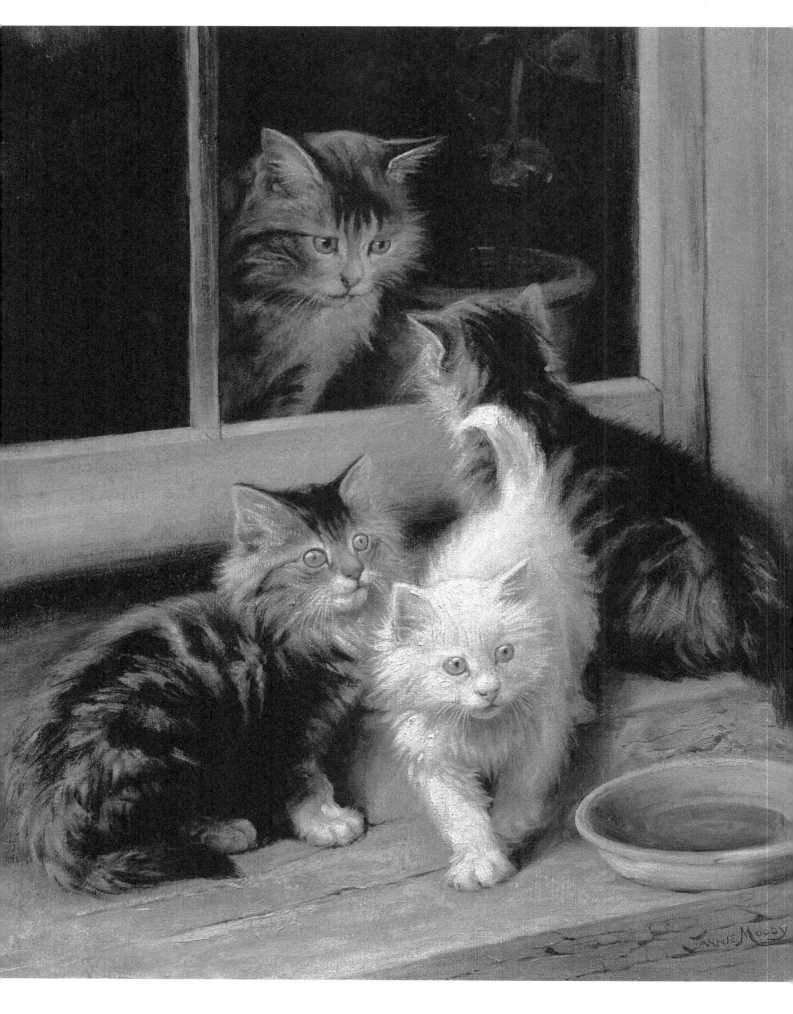

PAWS

Cats, like most mammals, walk on their toes. (Bears and humans are exceptions.) The cat's neat, little round feet are made up entirely of the small bones of its toes. The heel is halfway up the hind leg and its wrist a third of the way up the front leg. Each claw can be retracted to disappear into the fur and soft tissue.

1. Lightly draw a hind paw and front paw from the side and three-quarters. I always indicate the direction of the fur at this early stage. (See A.)

2. Add shading and more fur detail with pencil. Notice the shaping of the surface from the muscle and bone beneath. (See B.)

3. Using colored pencil, lay out the look you would like to achieve in the finished art. I use pale colors at this stage: blues, pinks, lavenders, and yellows. (See C.)

4. Add watercolor using a small brush. Stroke in the direction and the length of the hairs. Keep each color light, and layer colors for a rich look. (See D.)

5. For the white paws, be careful to stop while the shading is still delicate and pale. (See E.)

front foot

hind foot

front foot pads

Think of the cat paw as a soft little round cushion. The outline back to the wrist bones in the front paws is convex while the long outline from the ankle to the paw is straight. Cats walk on little tough furless pads under each digit with a larger pad nestled in between them.

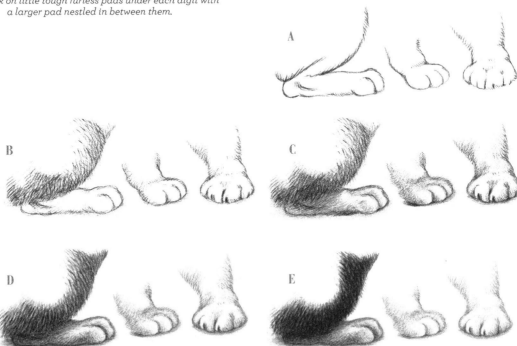

A

B

C

D

E

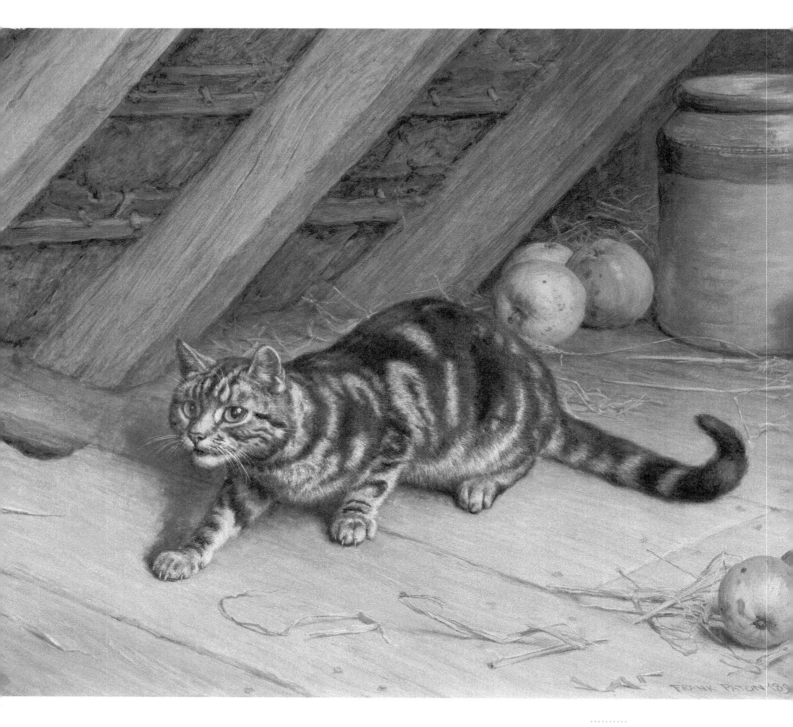

CLAWS

Almost all cats have retractable claws, while the dog family does not. Knowing where the claw emerges from the paw will help your art be more naturalistic.

1. Sketch the front paws with claws extended and fur patterns around them. Notice the fur separation above the claws. (See A.)

2. Add pencilwork as an underpainting. The penciled fur texture and pattern will shade your watercolor. (See B.)

3. Wash a warm pale yellow-brown over everything. Your pencilwork is now part of the watercolor. Add more fur color with pencil and brush. For crisp hair lines, work wet on dry. (See C.)

4. Using a small brush, add small hairs around the toes and longer ones on the legs. A little final shading and another wash over everything, and you are done. (See D.)

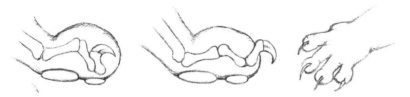

When the claw is withdrawn, the final section of the toe is retracted into the cushion of the paw. The claw can spring out when the cat straightens its toe. Each claw has a sheath that sheds and regrows. Grooming keeps the nails healthy.

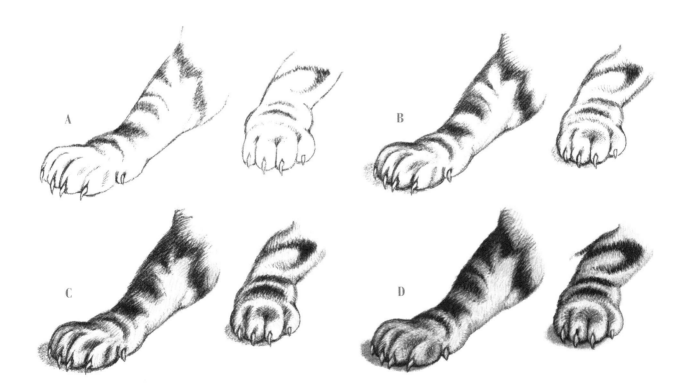

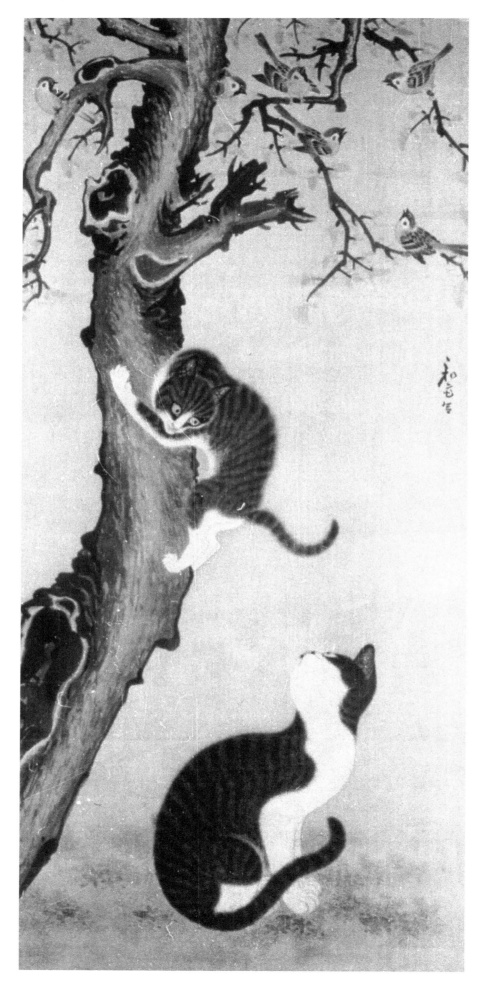

Cats, ink on silk, Pyon
Sang-Byok, Korean,
17th century / National
Museum, Seoul, Korea
/ Bridgeman Images

TAILS TELL THE TALE

Korean artist Pyon Sang-Byok's careful observation of nature and fondness for portraying cats are apparent in this depiction of a frightened kitten and its calm companion.

1. When a cat bristles, its tail hairs stick straight out from the skin. This is a bottlebrush tail. When the cat is calm, the hair lies flat. Your preliminary sketch should show this difference. (See A.)
2. Add detail. For the bristling fur, the darker line work should be toward the core of the tail, leaving the edges open and feathery.

I used a blue-gray outline for the legs of the calm cat. (See B.)

3. With colored pencil, indicate the color choices you might make in watercolor. Remember, stay light at the edges of the bristled tail. (See C.)
4. Put washes over the colored areas of the tails. Let each layer dry before adding the next. (See D.)
5. Use a little brush with fine strokes to add to the fur texture and darken the cats. (See E.)

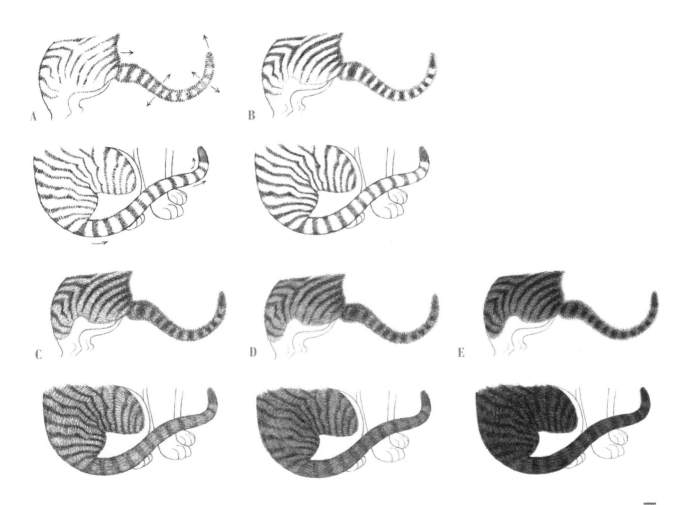

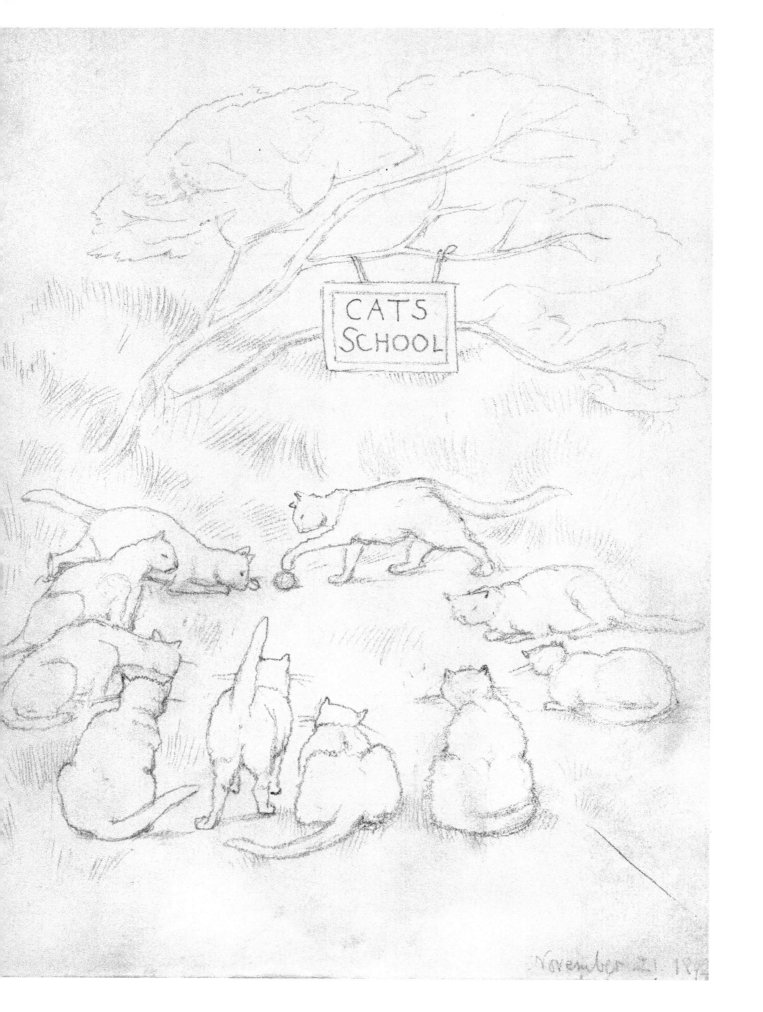

CATS
SCHOOL

November 21. 1892

BODY PROPORTIONS

No proportion formula fits all cats, but there are general proportional guides. I have included two here: the skeleton proportion grid and the head-neck measuring length. Try them both. (See A.)

Foreshortening—drawing anything that is pointing toward you—is one of the most difficult aspects of composition. If you think of the cat's body as a series of shapes stacked on top of each other, you will be able to foreshorten more easily. (See B.)

1. Using the head-neck unit of measurement, sketch three lateral cats. Then erase the proportion lines. (See C.)
2. Observe and add details. These cats have expressive poses and are very accurate in their proportions. (See D.)
3. Finish using line exclusively. This is an opportunity to discover the possibilities of this type of drawing. (See E.)

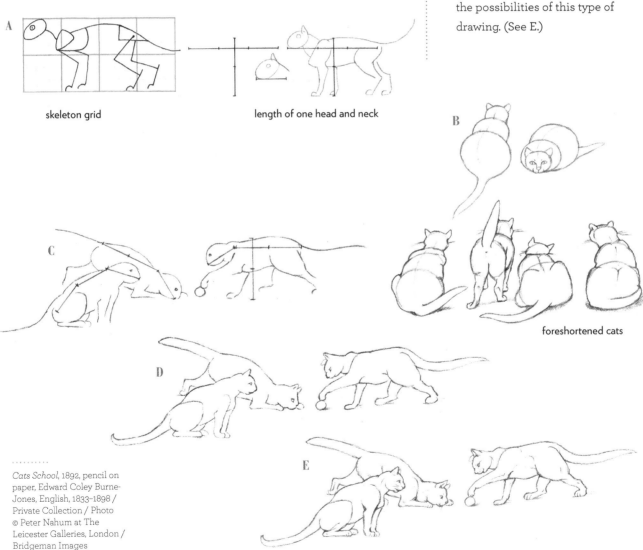

A

skeleton grid

length of one head and neck

B

foreshortened cats

C

D

E

Cats School, 1892, pencil on paper, Edward Coley Burne-Jones, English, 1833–1898 / Private Collection / Photo © Peter Nahum at The Leicester Galleries, London / Bridgeman Images

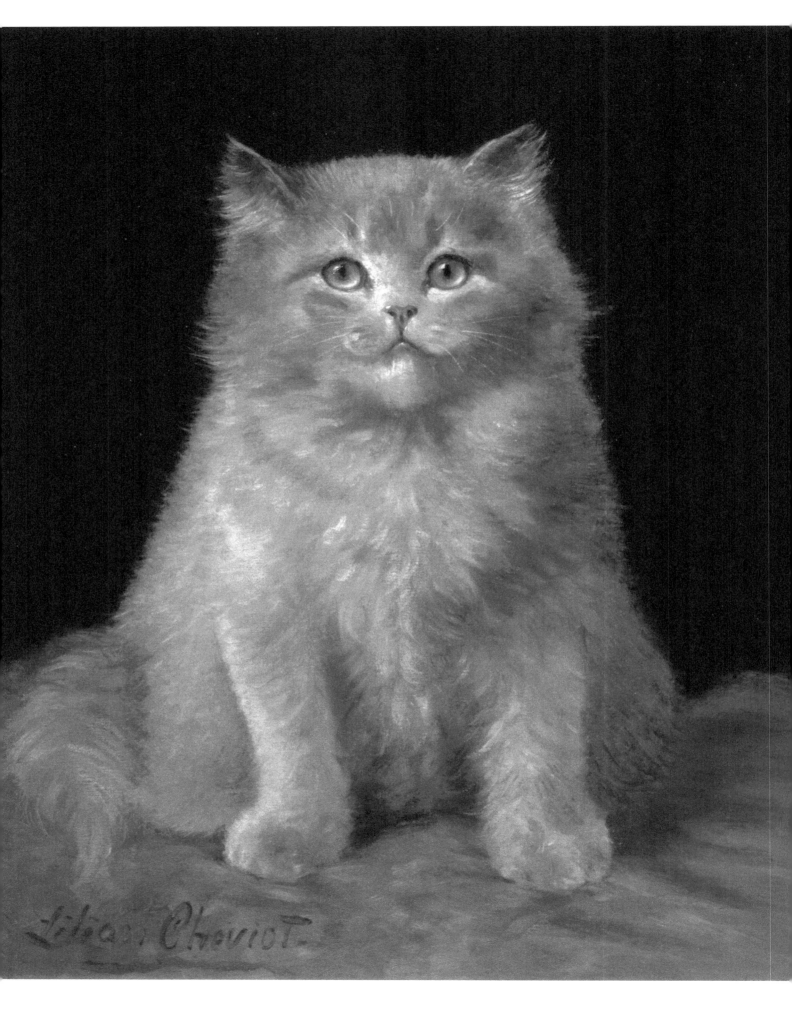

FAT CAT

This chubby kitten might not actually be a fat cat under all that fur. I did a little enlarging as you will see.

1. I used shapes to broaden the kitten. Each form is just a little wider than the painting's subject. (See A.)
2. After rotund proportions were achieved, I refined the shapes and softened the edges with directional fur strokes. (See B.)
3. I added pencil shading for volume and texture, then worked to capture that smug expression. (See C.)
4. Blue, violet, and gray pencil provided fur color and volume. The eyes combine green, yellow, blue, white, and black pencil. (See D.)
5. Pale blue-gray paint and small brush strokes textured and intensified the roundness of the cat's form without losing the white fur color. I added gray for the nose and yellow-green paint for the eyes. When the paint dried, I added a spot of opaque white to each eye. (See E.)
6. Making the shadows dark even on a white cat adds the drama of contrast to an image. (See F.)

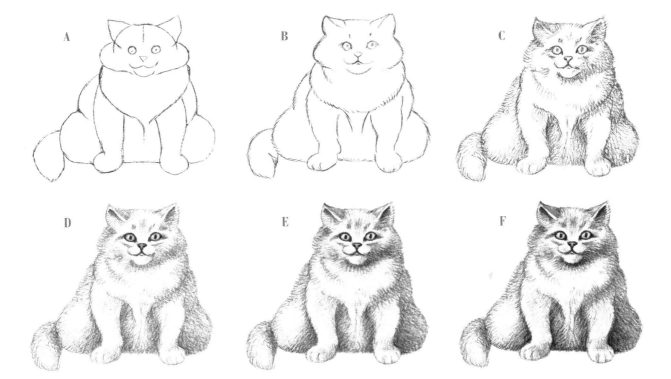

Study of a Cat, oil on canvas, Lilian Cheviot, English, fl. 1895–1911 / Private Collection / Bridgeman Images

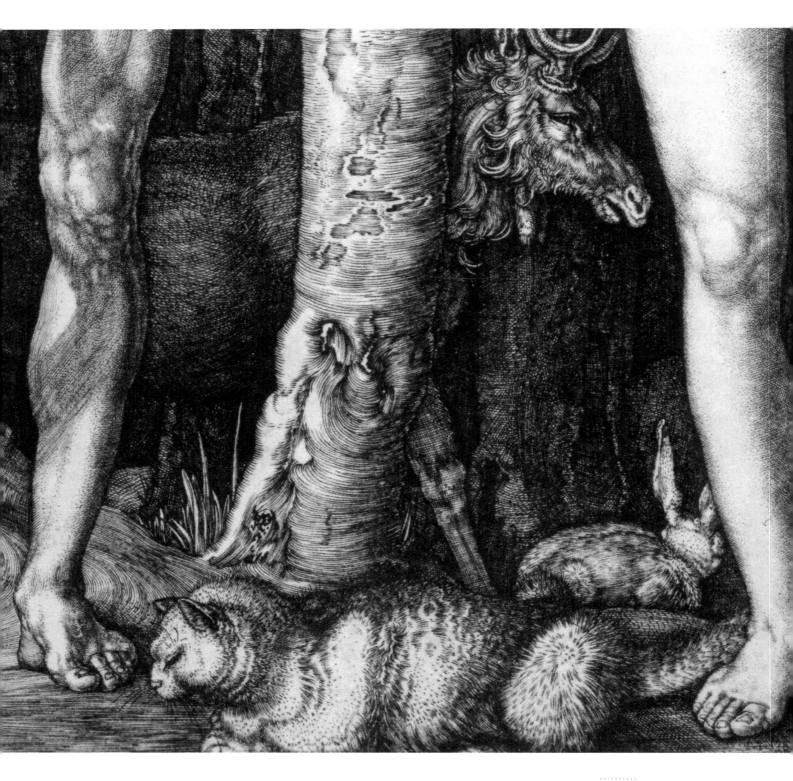

FUR TRACKS: WHICH WAY DOES THE FUR GROW?

With his sharp eye for nature, the great master of line Albrecht Dürer shows his viewer the direction of fur growth on his cat. This pattern on a mammal's body is called the fur track.

Fur grows in different directions over the cat's body. Use the diagram with fur track directions to inform your drawings.

1. Dürer divides his cat into primary shapes. You can use these to start your drawing. (See A.)
2. Refine the shapes. (See B.)
3. Pencil in some fur tracks, and you are ready to ink. (See C.)
4. Ink the outline of the cat using the fur as the shape-defining strokes. I use a very fine ink pen. A Micron pen works very well. (See D.)
5. Ink the fur all over. You will find that the fur direction shapes the cat without shading. (See E.)
6. Shade by layering strokes in the darker areas. Layer strokes only over areas that have dried. (See F.)

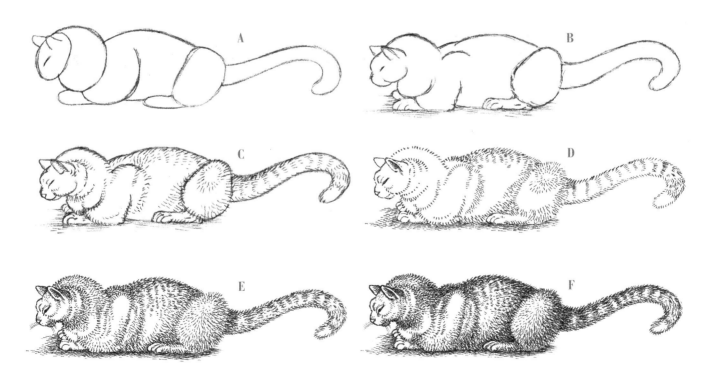

SHORT FUR

Jean-François Millet painted a softened, melancholy world of French peasant workers. In this beautiful pastel, the affectionate cat rubbing a woman's leg exemplifies Millet's vision. I am fascinated by the technique the artist used to draw this short-haired cat.

1. Do a quick proportional sketch. (See A.)
2. Follow Millet's lead in drawing the black lines, some squiggly, some straight. (See B.)
3. To put the pale olive yellow shadow behind the drawing, use a watercolor wash over the drawing. Use yellow, green, and orange colored pencils. (See C.)
4. Squiggles of pale green opaque watercolor on the tail, on top of the head, and on the fluffy sides highlight the shapes. (See D.)
5. Switching to oil pastels brightens the image. (See E.)
6. Finish with some more black lines and background details. (See F.)

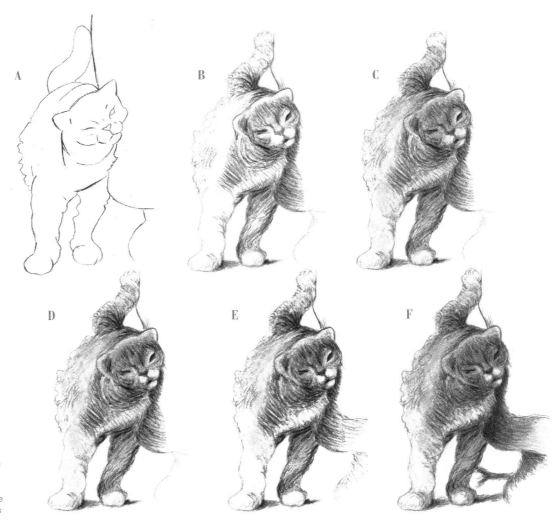

(Detail) *Churning Butter*, 1866–68, pencil & pastel on paper, Jean-François Millet, French, 1814–1875 / Musee d'Orsay, Paris, France / Bridgeman Images

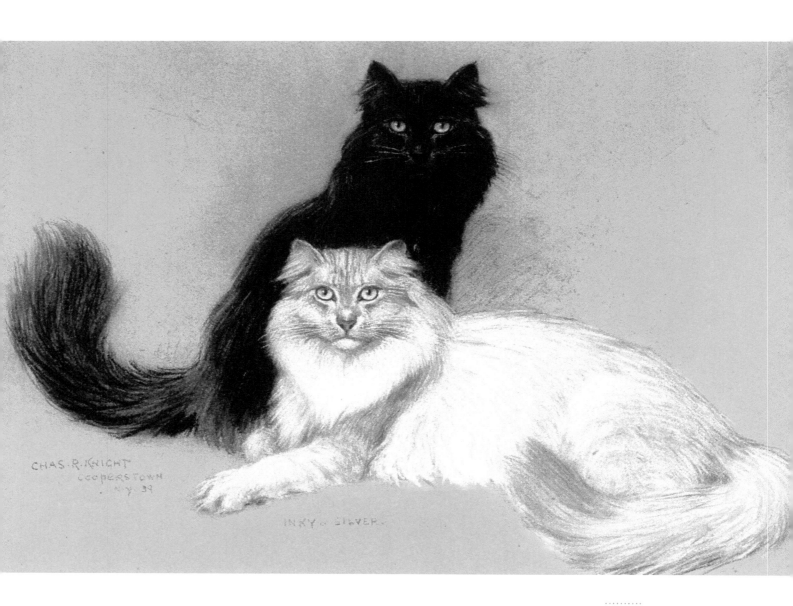

Inky and Silver, pastel,
Charles R. Knight.
American, 1939 / Collection
of Rhoda Knight Kalt /
charlesrknight.com

LONG HAIR

Charles R. Knight is an artist best known for his pioneering realistic murals of dinosaurs and the prehistoric world in the great American natural history museums. He was a master of animal anatomy and art in the service of science, but this is a pastel drawing of his two long-haired cats Inky and Silver. It is a family portrait still on his granddaughter's wall. Notice the use of long pencil strokes to simulate Silver's long hair and to shade the form.

1. Sketch Silver using large shapes: head, mane, legs, body, haunch, and tail. (See A.)
2. Continuing with pencil, refine the borders with long directional fur strokes. (See B.)
3. Paint the eyes, nose, and paw pad. Now Silver is alive. Lightly indicate all the fur. Remember, long strokes indicate long fur. (See C.)

4. Blue and lavender lines with a little pink indicate Silver's color. Again, use long strokes. (See D.)
5. For the darker areas, use more pink, light blue, and darker lavender. Glazing the lines with white pencil intensifies and blends all the colored pencil strokes. (See E.)
6. As my personal last touch, I used a very small brush to stroke neutral tint with a little blue over the long fur and at the end of the tail plume. (See F.)

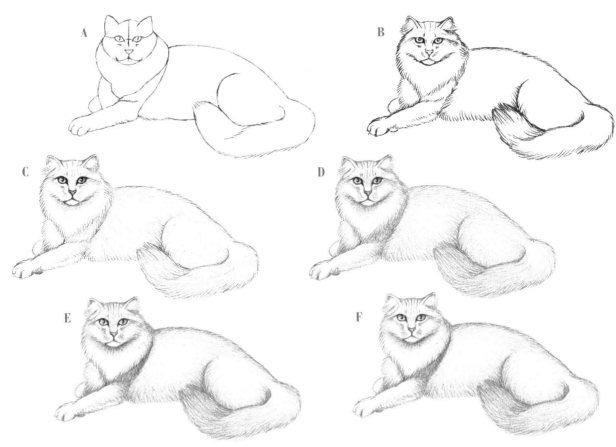

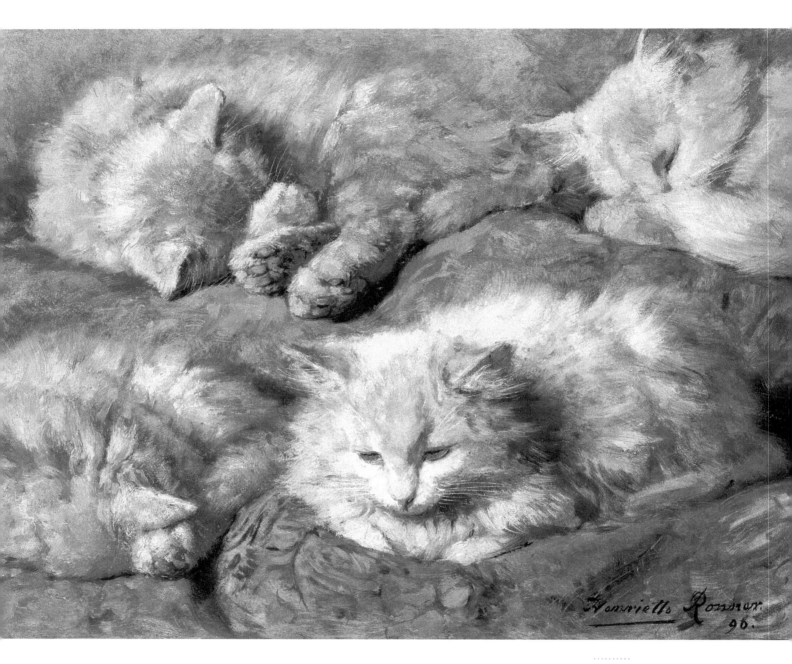

*Studies of a Long-haired White
Cat*, 1896, oil on panel, Henriëtte
Ronner-Knip, Dutch, 1821–1909
/ Private Collection / Photo ©
Christie's Images / Bridgeman
Images

FUZZY FUR

Try a few experimental texture patches like this one. I decided that pencil would be an appropriate medium.

The first thing one notices when examining these appealing fuzzy cat studies is that there is hardly a hard edge anywhere. Unlike the long-haired cat with its flowing linear shapes, the fluffy cat presents few edges. So, what is a good way to approach this problem?

1. Except for the ears and feet, define the cat's shape with broken lines. Using solid outline for this soft shape will present problems at every step, so keep the edges soft and uneven. (See A.)

2. I used a gray pencil to correct details and then proceeded to shape a rounded form. (See B.)

3. To continue rounding the cat beneath the fur, use small amounts of pale blue, cream or light yellow, lavender, and more gray. Darken the shadows. (See C.)

4. Color the paw pads, touch in the final color accents, and add a shadow so that your cat appears to be firmly lying on the ground. (See D.)

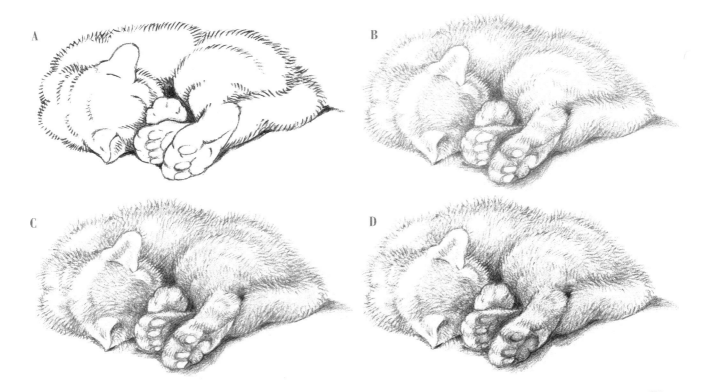

A

B

C

D

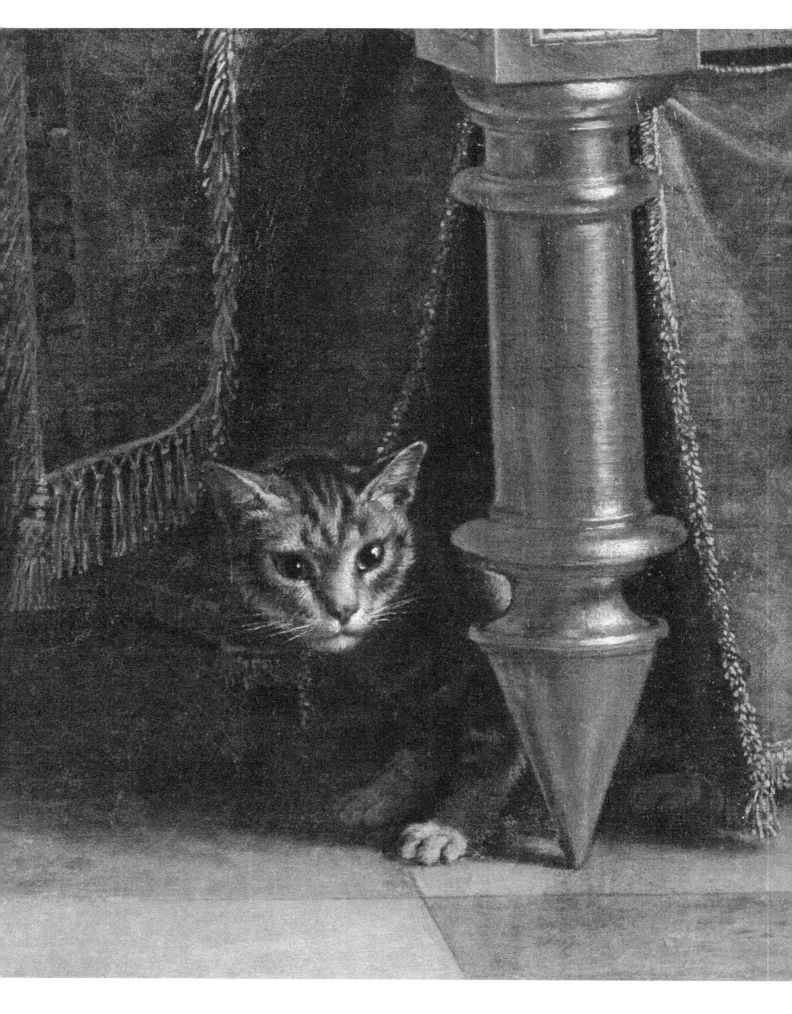

SHINY COAT

Philippe de Champaigne is best known for his piercing portraits of Cardinal Richelieu. Perhaps the painter's famous patron was pleased by this beautiful, glowing cat peeking out from below the couch in a large painting. The cardinal loved cats.

1. Think of drawing this beautiful cat as if you were drawing a portrait and are determined to catch the likeness. Do a careful and detailed preliminary sketch. (See A.)

2. Add stripes and shading. What makes this cat's face shine is the bright glow of the fur. To simulate this, leave several clean white areas. (See B.)

3. After coloring the eyes, use a gray-black watercolor with a hint of thalo blue to concentrate on the muzzle area. This part has the least shine, so it is a safe area for experimentation. Make the shadows soft edged and the white bright. The face has begun to glow! (See C.)

4. With the knowledge gleaned from doing the muzzle, cover the rest of the head with the same colors. Lightly use some pale green and yellow in the soft shadow areas. Check the likeness. (See D.)

5. Darken the drawing where needed, and don't forget to add the whiskers. (See E.)

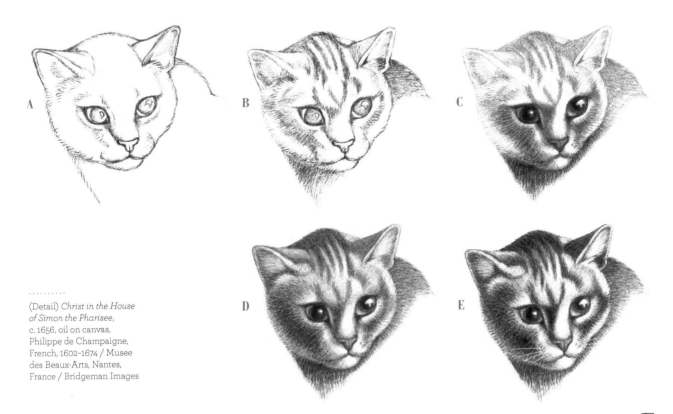

(Detail) *Christ in the House of Simon the Pharisee*, c. 1656, oil on canvas, Philippe de Champaigne, French, 1602–1674 / Musee des Beaux-Arts, Nantes, France / Bridgeman Images

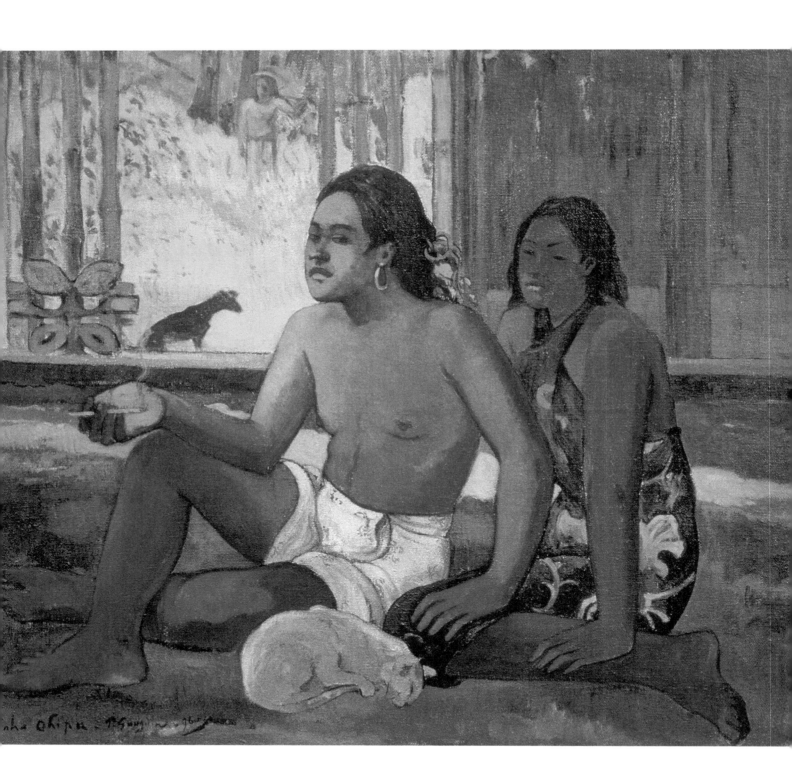

WHITE CAT

A white cat appears in several of Paul Gauguin's Tahitian paintings. So inspired was Gauguin by the colors of the islands that even his white cat is a rainbow. White and black subjects often tax art students, but when one begins to see all the colors present in these two seemingly stark tones, the problems disappear.

1. A quick, clean ovoid shape with paws and a head sets the mood of this piece. (See A.)
2. Use a blue gray pencil to shade the form. Keep it clean and simple. (See B.)
3. Lay in light colored pencil where colors might work. Use this as an experimental step in preparation for the paint. (See C.)

4. Red, yellow, lavender, and blue over the first layer of pencil color will build up the rainbow cat. (See D.)
5. A light wash of blue gray will soften the colors and unify them. It also casts a shadow over the cat holding its own tail. (See E.)

Eiaha Ohipa or *Tahitians in a Room*, 1896, oil on canvas, Paul Gauguin, French, 1848-1903 / Pushkin Museum, Moscow, Russia / Bridgeman Images

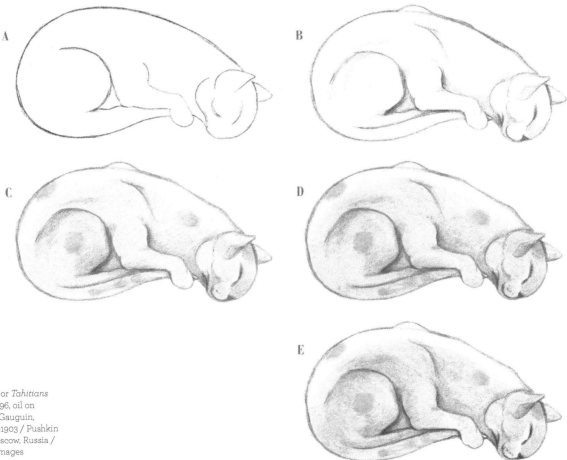

A B C D E

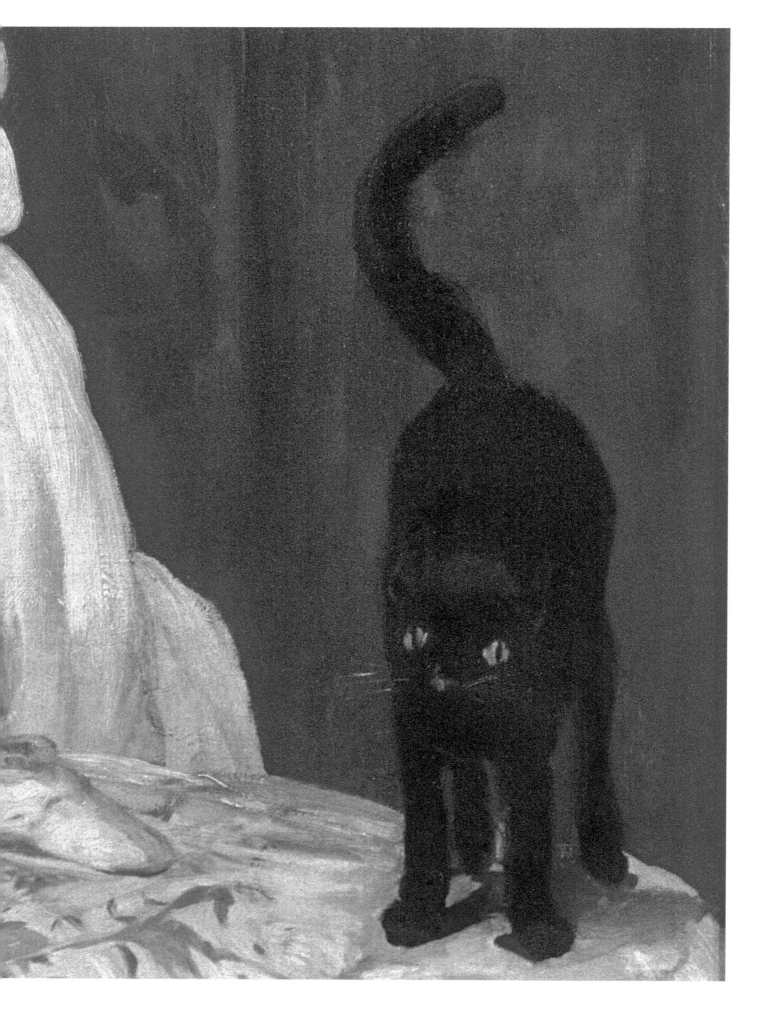

BLACK CAT

Édouard Manet's *Olympia* is one of the most famous paintings of the last 150 years, but how many viewers notice the little black cat at Olympia's feet? This animal is so full of charm and happiness that I cannot agree with those art historians who call it a demonic symbol.

1. The soft S curve of the cat's body gives it a lively feeling even as it stands still. Use a line from the tip of its tail to its nose to assure your drawing reflects the spine's sweep. Stack the shapes of the fore limbs, belly, and hind end one in front of the other to achieve foreshortening. (See A.)

2. Here's where your developing knowledge of cat anatomy comes into play. Refine your simple outline to make it as catlike as you can and don't forget those whiskers. (See B.)

3. Some white highlights will show through the cat's dark silhouette. Add these highlights as if you were drawing a white cat. Use pale colors as well as white. Paint the eyes and nose. (See C.)

4. Brush a wash of black watercolor over the drawing. Keep it diluted. The pale blue and white pencil will resist the watercolor. Use white pencil again after the paint dries. (See D.)

5. To make the cat a rich black, use several successive coats of black watercolor paint. Let each coat dry before you add the next. Touch up the highlights after the black area is finished. (See E.)

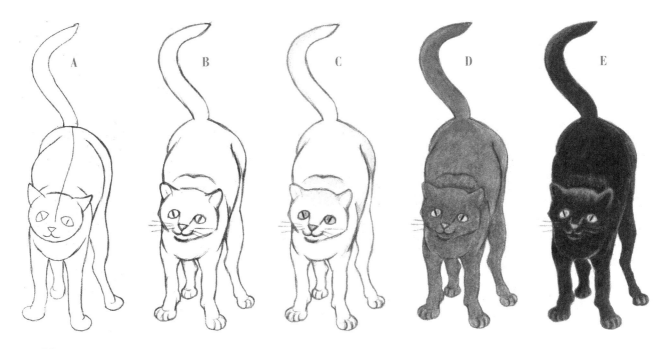

(Detail) *Olympia*, 1863, oil on canvas, Édouard Manet, French, 1832–1883 / Musee d'Orsay, Paris, France / Bridgeman Images

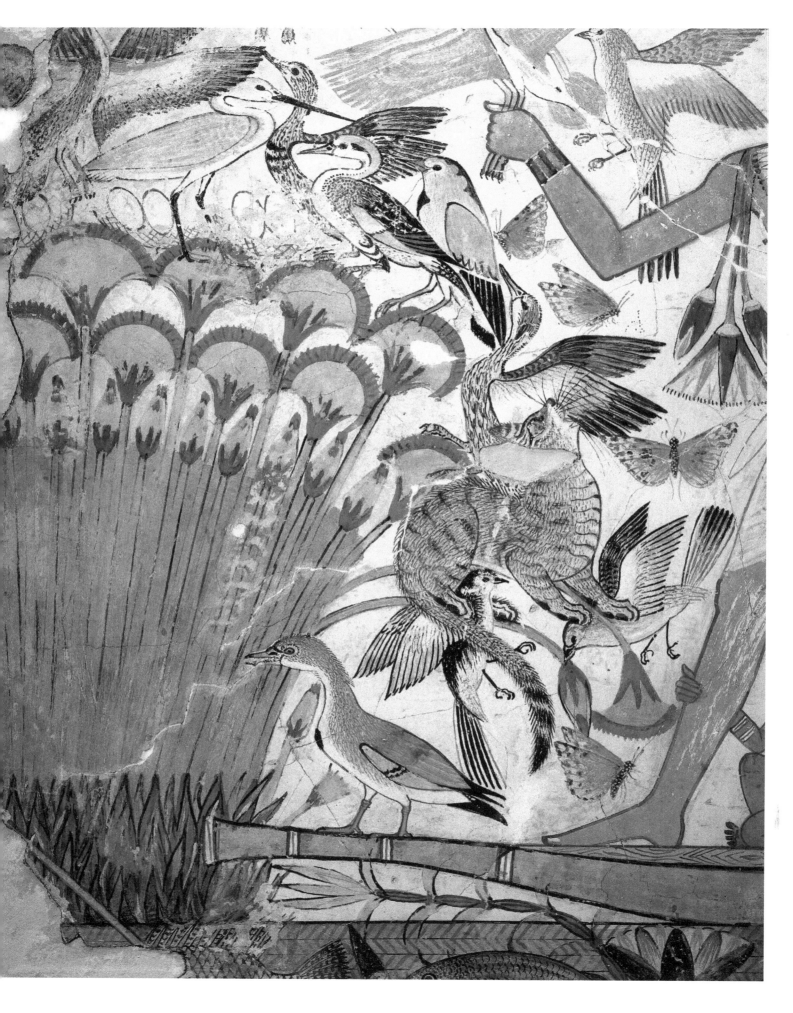

STRIPED CAT

Cats were already domesticated and a prominent feature in ancient Egyptian art when Nebamun's hunting scene was painted some 3,400 years ago.

1. Draw a clean, simple outline of the cat and entwined birds. (See A.)
2. Observe and add all the black detail that is needed on the birds. Try using a fine black waterproof marker. (See B.)

3. Finish the black line work. Concentrate on the cat's stripes. (See C.)
4. Next stroke brown paint over the cat's black lines. You could also use a brown waterproof marker. Use watercolor to paint the birds. (See D.)

5. Paint the cat with flat strokes of yellow-brown. Leave the white areas unpainted. Use pale burnt umber watercolor for the shading. Be sparing with the darker paint. (See E.)
6. To richen the colors, add another coat of paint. It is better to build up color than go dark all at once. (See F.)

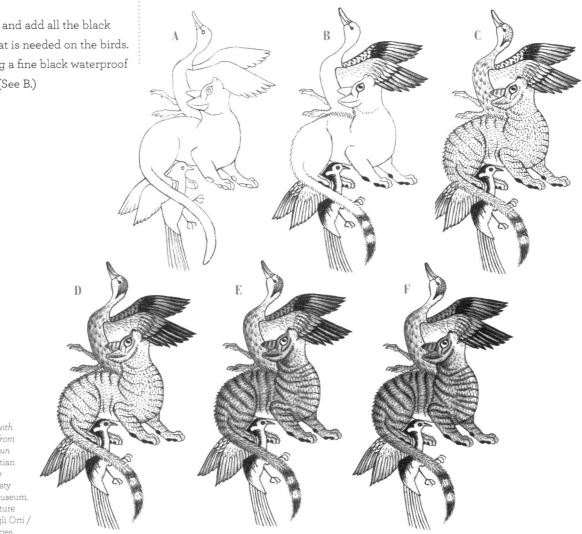

(Detail) *Fresco with Hunting Scene from Tomb of Nebamun at Thebes*, Egyptian civilization, New Kingdom, Dynasty XVIII, British Museum, De Agostini Picture Library / G. Dagli Orti / Bridgeman Images

The Laundress, c. 1735, oil on
canvas, Jean-Baptiste-Siméon
Chardin, French, 1699–1779 /
The Barnes Foundation,
Philadelphia, Pennsylvania, USA /
Bridgeman Images

BRINDLE CAT

This calico cat belonged to Chardin, who painted it many times in his scenes of household life. In a foreshortened "meatloaf" pose, this cat appears particularly comfortable and inviting.

1. In drawing cats with multiple colors, be sure to retain the animal's solid form. Use the stacking-shapes method to foreshorten the pose. A midline will help keep the parts in alignment. (See A.)

2. Refine the shape. Add shading for form and to indicate black areas. Keep your colors and line faint at this stage. (See B.)

3. Yellow ochre, orange, and black pencil indicate the colors of the cat's coat. (See C.)

4. Paint yellow ochre over the shaded areas of white fur. (See D.)

5. Paint a rusty orange over the red fur areas and over the black pattern as well. This will make the black areas richer when you paint them. (See E.)

6. Add the black paint. Use a little pale brown for extra shading if needed. Chardin's cat is finished. (See F.)

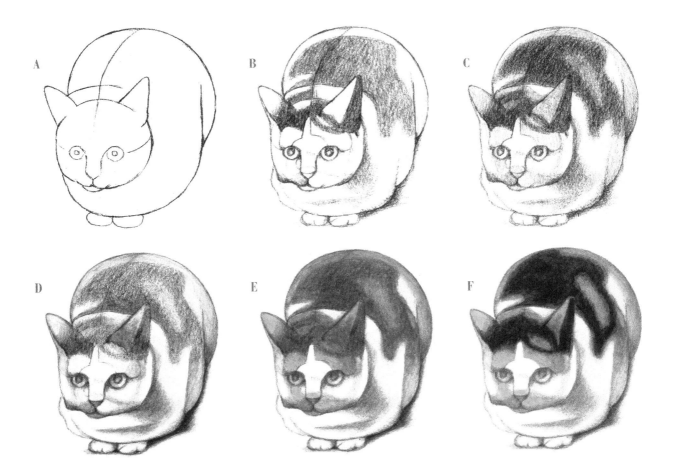

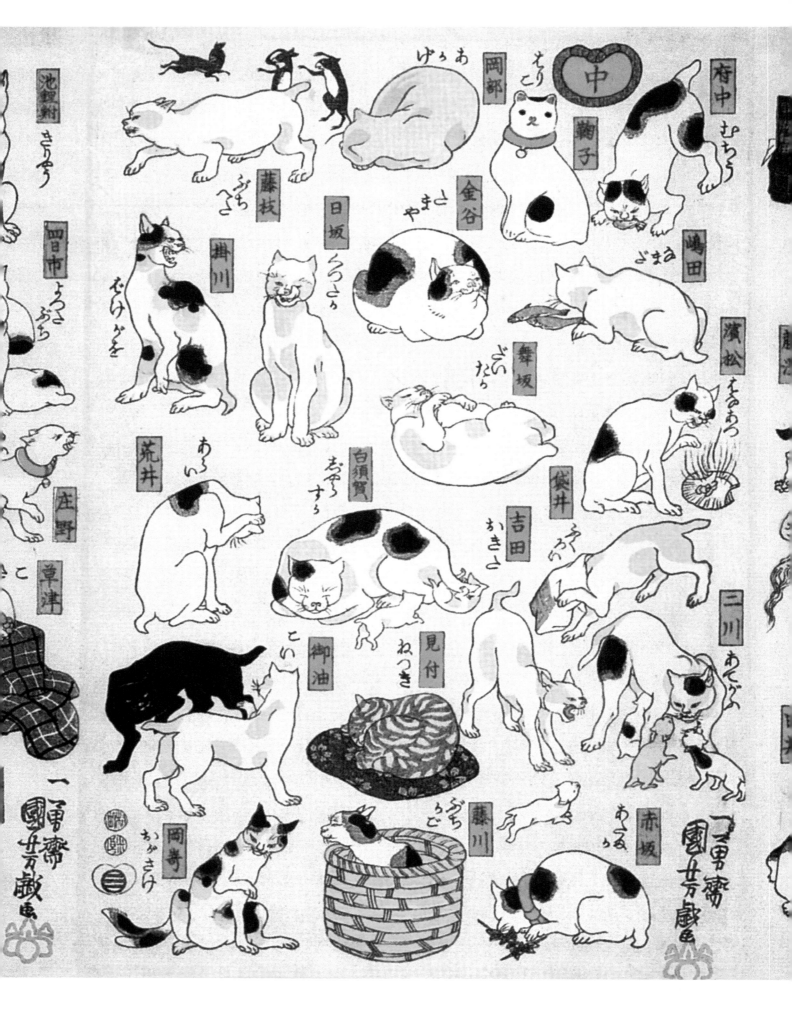

CATS OF MANY COLORS

I selected a small grouping of the fifty-three cats in Utagawa Kuniyoshi's ukiyo-e print. (See next page.) The cats represent the fifty-three stops on the road to Edo and Kyoto but they also sing loudly of Kuniyoshi's understanding and love of cats in all their diversity.

1. Construct a simple line drawing of the major forms in each cat. Medial lines for spine and head are always useful. Make the pencil light so that it can be cleanly erased. (See A.)

2. Add details and correct the outline, still drawing lightly. (See B.)

3. Ink the lines to make them bold like those of a woodblock. Any ink will do for this step as long as it is waterproof. (See C.)

4. Pencil in the patterns on the cats and pillow as watercolor guide lines. (See D.)

5. Add the watercolor. I put brown pencil over the watercolored stripes of the sleeping cat to give it some of the texture of the original. (See E.)

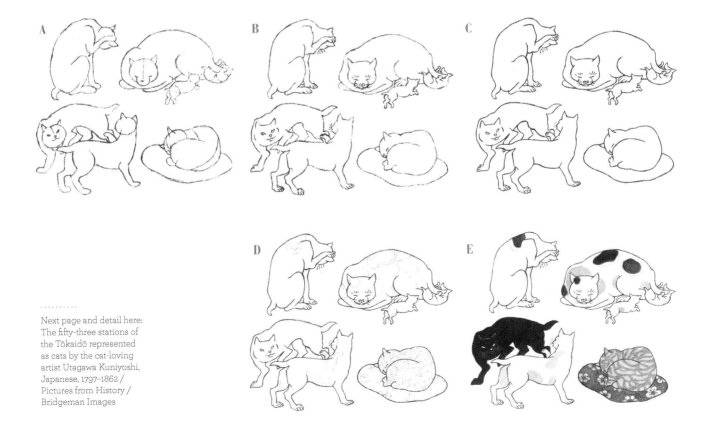

Next page and detail here: The fifty-three stations of the Tōkaidō represented as cats by the cat-loving artist Utagawa Kuniyoshi, Japanese, 1797–1862 / Pictures from History / Bridgeman Images

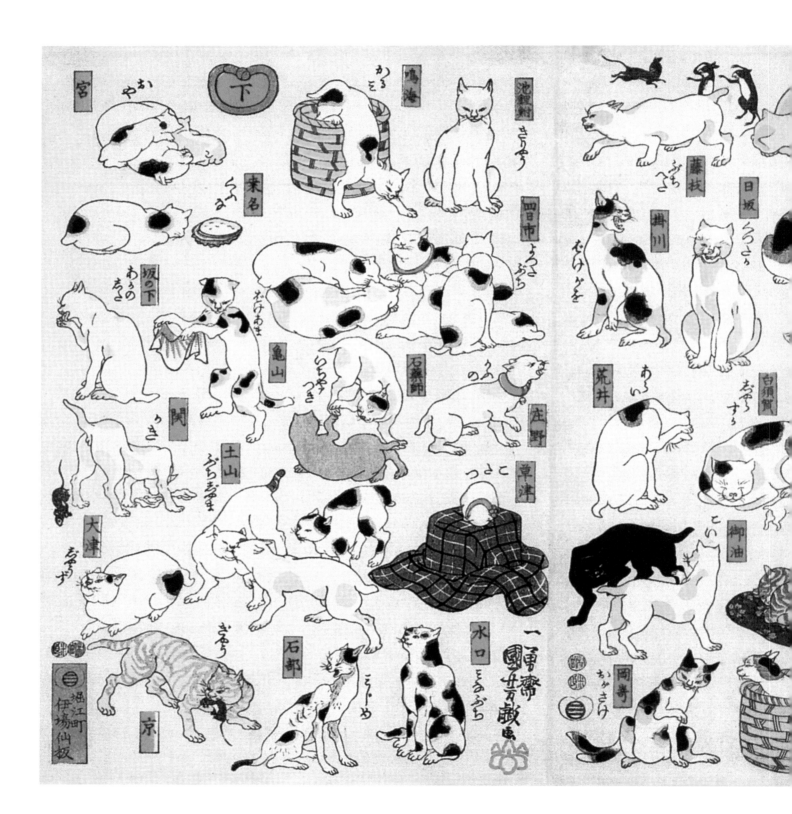

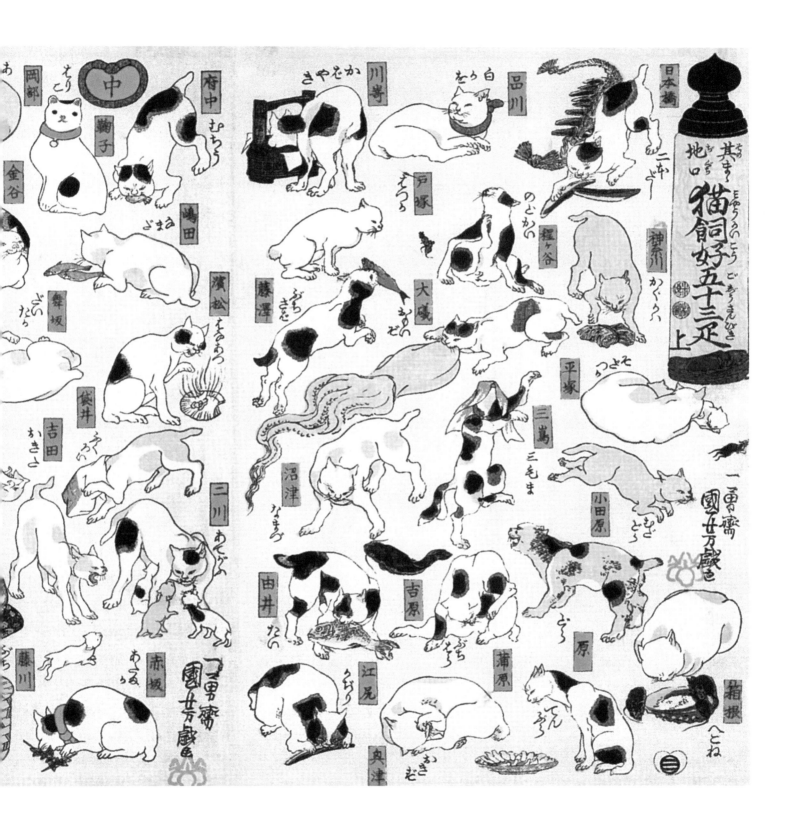

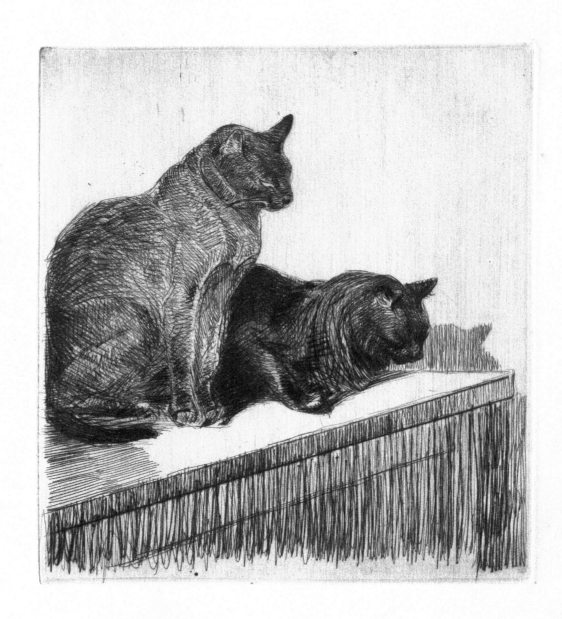

3ᵉ état L.

SITTING 1

Perhaps the most famous image of a sitting cat is also one of the oldest. Compare my drawing of an Egyptian bronze cat from the Metropolitan Museum of Art with Steinlen's cat.

This handsome etching was a surprise to me. I always stroke my lines in the direction of the fur track, but not so this artist. The line strokes are used to define the sculpted shape of this classic sitting cat.

1. Draw the elegant shape of the sitting cat. Make sure to get the haunches in the correct position. Charcoal would work well for this sketchbook study. (See A.)

2. Details, details, details! Planar form was very important to Steinlen. Think of this drawing as sculpture made up of flat shapes with contrasting curves. (See B.)

3. The shading accentuates the planar form, not the fur tracks. Concentrate on the flat planes while adding lines. (See C.)

4. Layer more strokes and vary the shades: as many as possible. Contrast always adds strength. A good exercise is to draw a panel and fill it with shading from black to almost white. (See D.)

5. Push some areas to black to finish the drawing. (See E.)

Deux Chats sur un Meuble, 1914, drypoint and etching on paper, Théophile Alexandre Steinlen, Swiss, 1859–1923 / Museum of Fine Arts, Houston, Texas, USA / gift of Marjorie G. Horning / Bridgeman Images

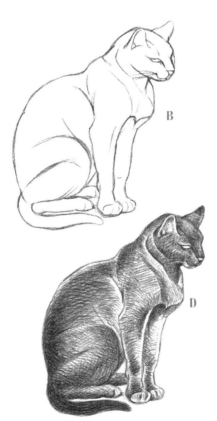

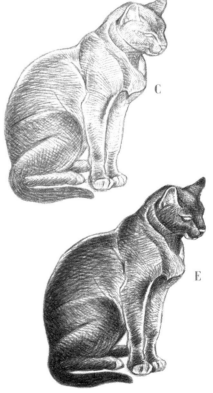

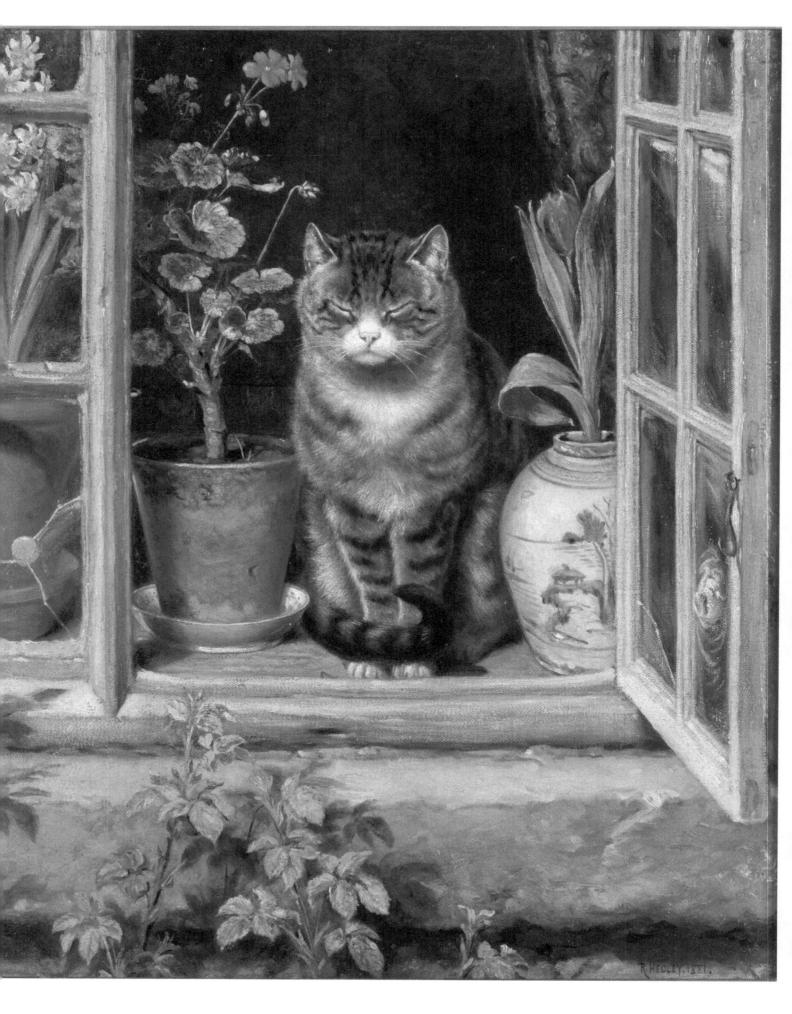

SITTING 2

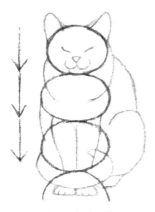

Using the head as a measurement, we see our cat is three and a half heads high. Only the haunches extend beyond the head circles.

Everyone likes to draw a front view of a sitting cat. A cat's seated shape is so forthright. After you do this project, try a front view without reference. You will be surprised and pleased.

1. Lightly draw the head circles and sketch the cat over them. (See A.)
2. This is a striped, short-haired cat. Indicate the stripes using short strokes in the direction of the fur growth. For now, draw only the dark areas and stripes. (See B.)
3. Add color between the stripes, continuing to indicate fur direction. I suggest burnt orange, dark brown, and yellow ochre as colors. (See C.)
4. Brush pale yellow watercolor over everything, then some red-brown and light brown. Be sure to let each coat dry before applying the next. Use short strokes with a small brush for the later layers. (See D.)
5. Use black and a fine brush to darken the stripes. To enrich the color, add as many little color strokes as you like. (See E.)

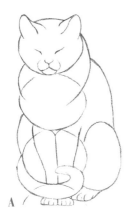
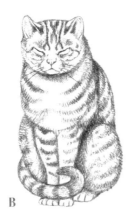
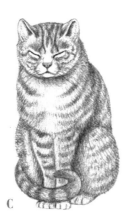
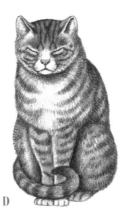
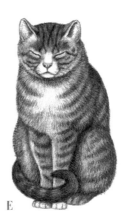

A B C D E

Blinking in the Sun, 1881, oil on canvas, Ralph Hedley, English, 1848–1913 / Laing Art Gallery, Newcastle-upon-Tyne, UK / © Tyne & Wear Archives & Museums / Bridgeman Images

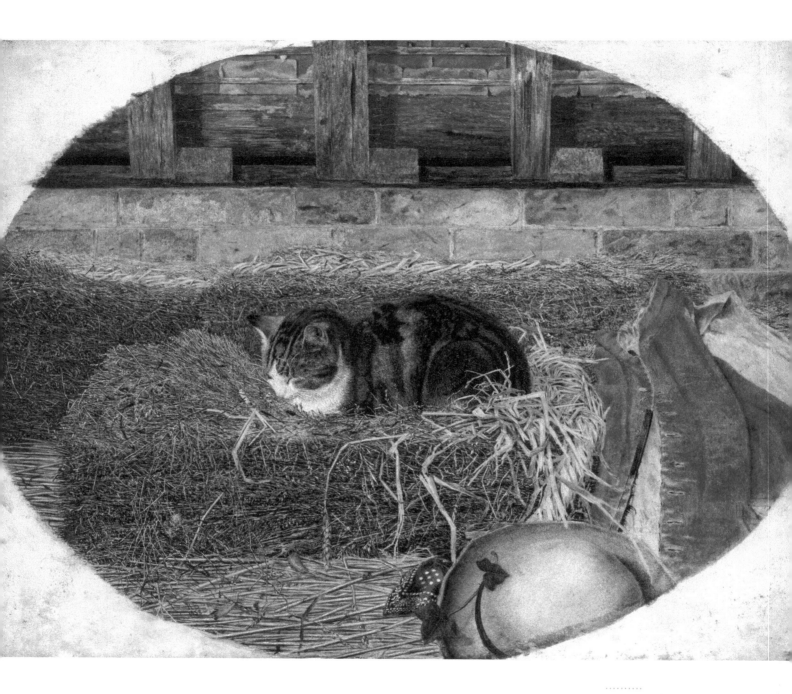

Catnap, 1858, oil on canvas,
Rosa Brett, English, 1829–1882
/ Private Collection / Photo ©
The Maas Gallery, London /
Bridgeman Images

SLEEPING CAT

A sleeping cat is another iconic pose, probably because the cat is still and stays that way long enough to be drawn. This is what I call the "meatloaf" cat pose.

1. Start with a line drawing indicating as much anatomy as is visible on the "meatloaf." (See A.)
2. In pencil, add the cat's stripes and a shadow under the sleeping cat. (See B.)
3. Using short lines to draw the dark stripes, move your pencil in the direction of the fur. Add the cat's color between the stripes. (See C.)
4. Color a light golden brown watercolor over all of the cat except for its white bib. (See D.)
5. Use small brush strokes to darken everything and shadow the white bib. (See E.)
6. Black will give the stripes punch. Adding brown brush strokes in the darker area will increase the illusion of a round form. (See F.)

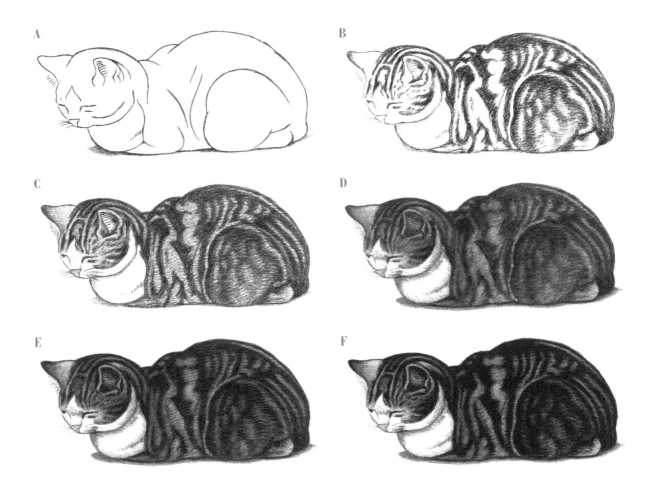

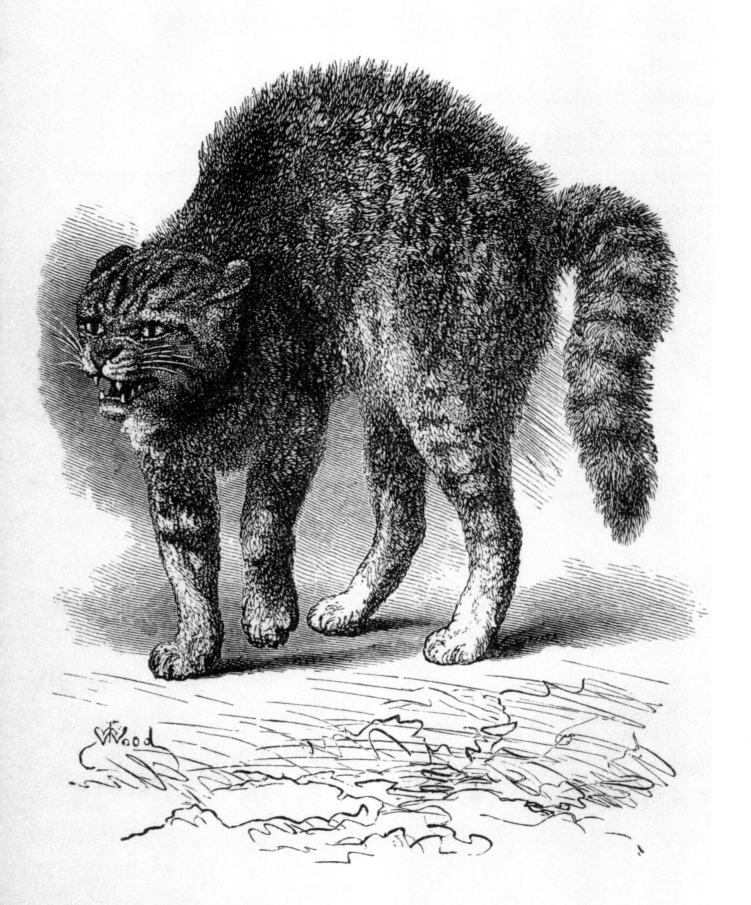

STRETCHING

Cats can stretch their supple bodies in many different directions. This cat has arched his back, standing tall on his toes while bristling with anger or fear. The line work emphasizes both.

1. Draw a light basic outline. Because it will be an ink drawing there is no problem with the outline flattening the bristling fur. The line will be erased. (See A.)
2. Add texture to guide your ink lines. I erased some areas to give the fur a disheveled appearance. (See B.)

3. Ink the cat, picking up all the hints of the pencil work. Erase the pencil completely. (See C.)
4. Add ink lines to indicate the stripes and parted fur. (See D.)
5. Continue inking to add contrast. (See E.)

A

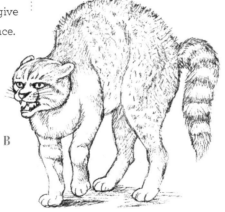

B

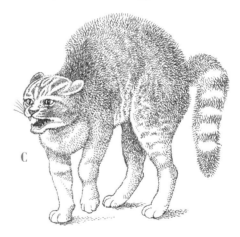

C

Cat terrified by a dog, from Charles Darwin's *The Expression of the Emotions in Man and Animals*, 1872, lithograph, Thomas W. Wood, English, fl. 1870s / Private Collection / Ken Welsh / Bridgeman Images

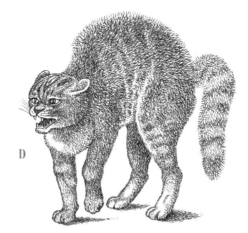

D

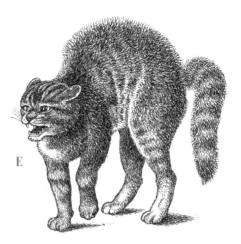

E

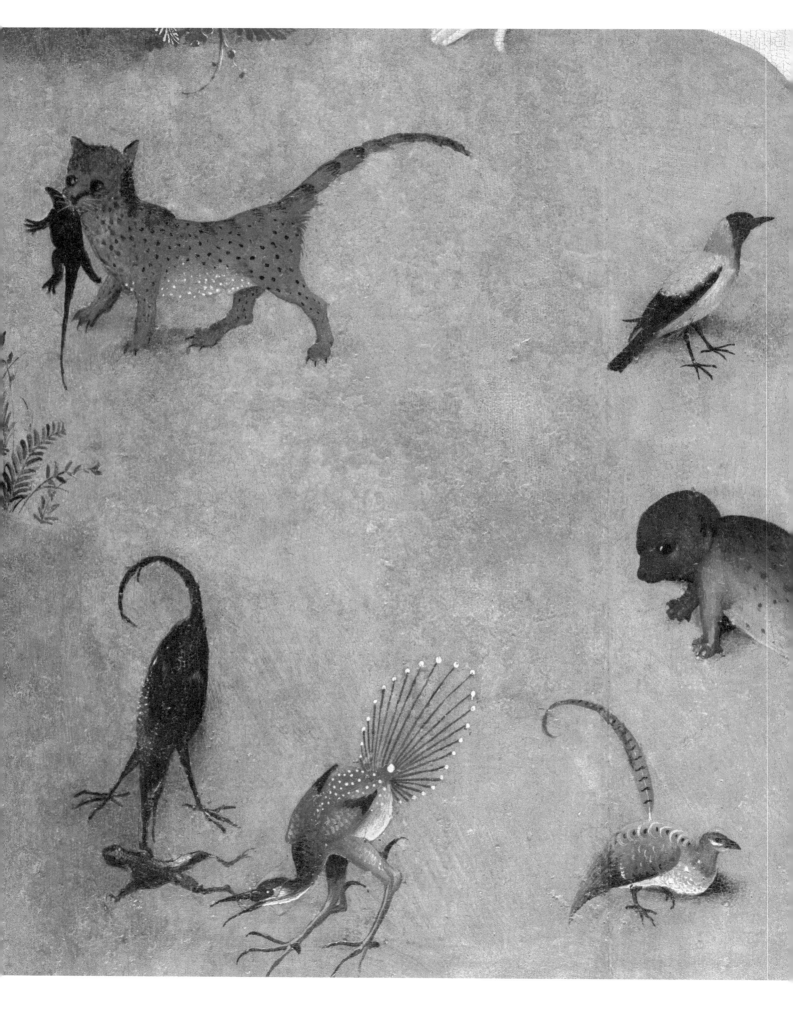

WALKING

Hieronymus Bosch's triptych *The Garden of Earthly Delights* remains enigmatic to this day, but the large spotted cat that appears in it looks completely familiar.

1. Do a light pencil sketch, noting the wonderful sweeping line of the belly up to the tip of the tail. (See A.)

2. Add more detail in pencil. (See B.)
3. Ink the basic cat and spots. Erase all the pencil lines. (See C.)
4. There are so many colors in this fantastic cat! I used watercolor layers of yellow, yellow-green, dark yellow, and lemon yellow. (See D.)
5. Brown watercolor over the green makes a good background for the spots. (See E.)
6. Blue spots, green spots, yellow spots, orange, brown, and red spots—Bosch's cat was really fun to do. (See F.)

A cat's walking gait moves the two legs on one side back, while the two legs on the other side move forward. Bosch's cat would be at the end of this sequence, with the legs on the cat's left side moving backward together.

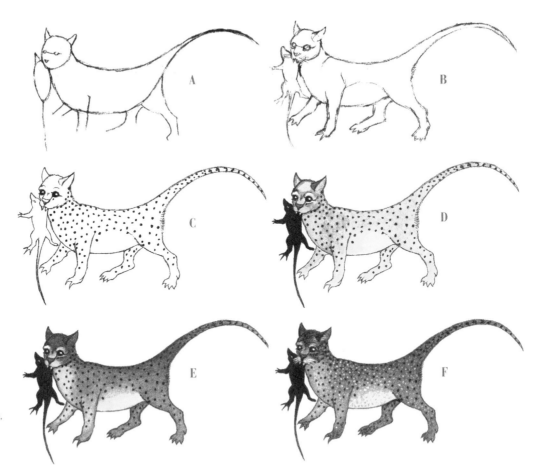

(Detail) *The Garden of Earthly Delights*, c. 1500, oil on panel, Hieronymus Bosch, Netherlandish, c. 1450–1516 / Prado, Madrid, Spain / Bridgeman Images

Kitten, English School,
gouache on paper, 20th
century / Private Collection
/ © Look and Learn /
Bridgeman Images

RUNNING

Cats have a beautiful running gait, soaring with all their paws off the ground at once.

1. Sketch with pencil the head, shoulder with forelimbs, barrel, hind limbs, and tail. (See A.)

2. Make the edges soft and add some stripe placement. (See B.)

3. Refine the stripes. Adjusting the kitten's head can be done in pencil as well. (See C.)

4. Loosely over-paint color for the coat, paw pads, eyes, and nose. (See D.)

5. Stroke brown paint in the direction of the fur over the stripes and lighter fur. Darken the pupil and line around the eyes and nose. (See E.)

6. A few coats of black paint on the stripes will finish the cat. (See F.)

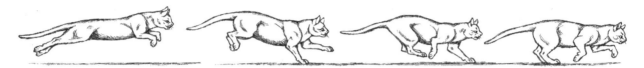

This drawing of the leaping, soaring cat includes accurately depicting the point in the gait in the painting (second cat from the left).

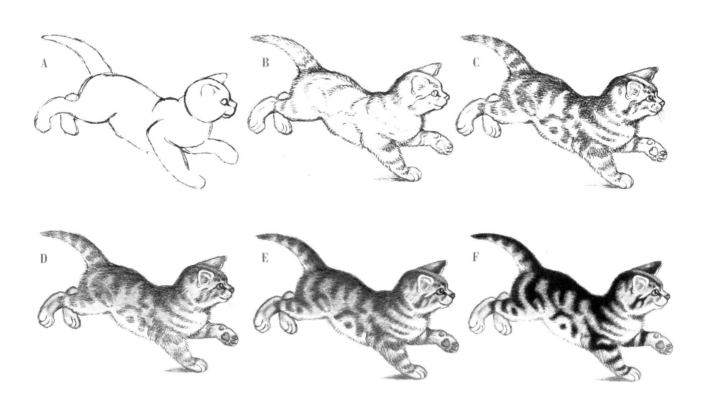

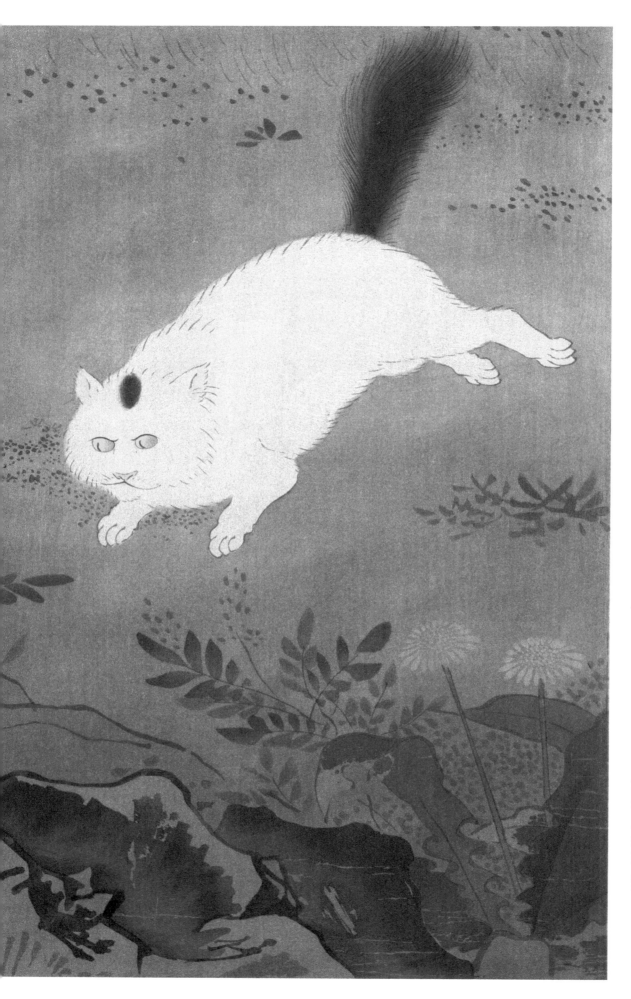

A White Cat, illustration from *The Kokka* magazine, published in Japan, 1896–1897, color lithograph, Lu Ji (or Lu Chi), Japanese, c. 1457–1503 (after) / Bibliotheque des Arts Decoratifs, Paris, France / Archives Charmet / Bridgeman Images

JUMPING

The seeming simplicity of this cat painting illustrates the artist's profound understanding of the animal. This sparsely rendered jumping cat is irresistibly energetic.

1. Sketch the big oval body, round head, and extended tail and limbs. Midlines on the spine and head keep the parts of the cat angled the same way. (See A.)

2. Erase what you don't need as you add detail. (See B.)

3. Darken the line work in preparation for the next step. (See C.)

4. Add a background wash. Paint the eyes and nose and add pink to the ears and toes. (See D.)

5. Use a small brush to go over the lines and tail. (See E.)

6. To keep the background from looking empty, use some of the green brush strokes of the original painting. (See F.)

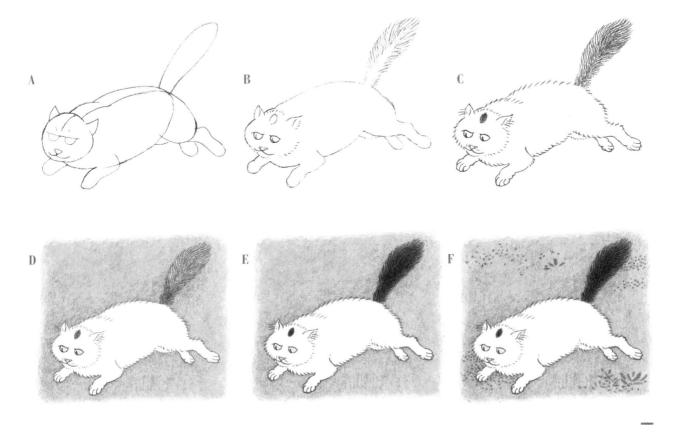

Use these leaping cats as a sketchbook reference for later work.

A

B

C

D

E

F

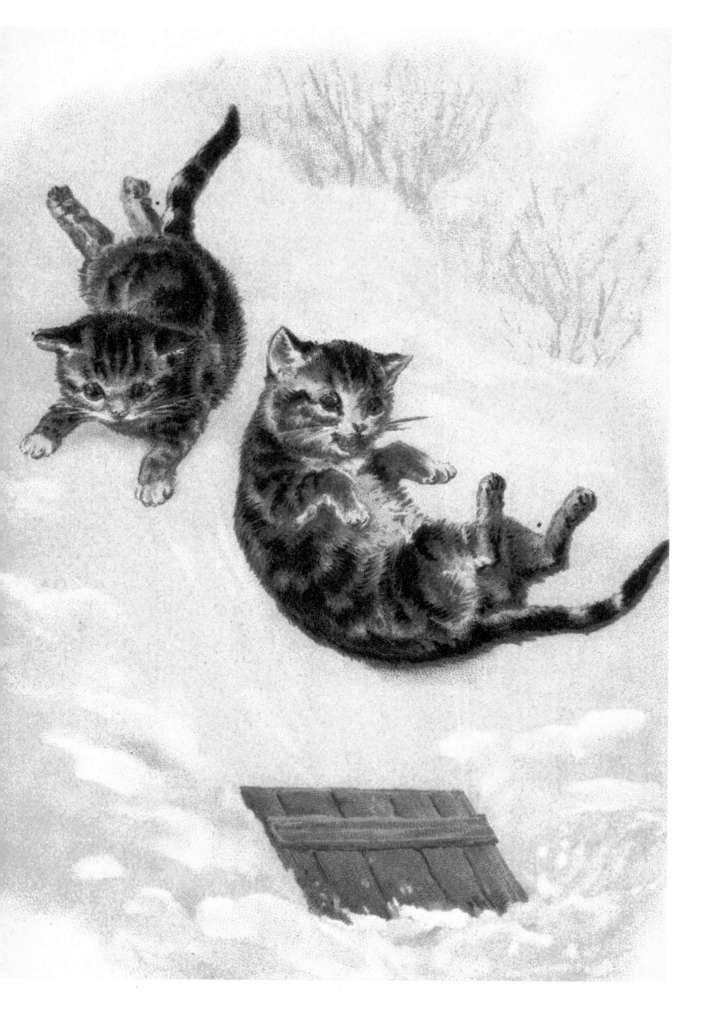

FALLING

Cats can control falls and turn them into a long jump landing. These two falling kittens seem quite unalarmed by their predicament. They also display wonderful sepia wash work.

1. Round body shapes, large kitten-sized head circles, and medial lines are good features of a first sketch. (See A.)

2. Add details such as the fur outline, wide eyes, and large paws. (See B.)

3. Mix a sepia brown with a lot of water. This will be a layered watercolor so mix a good-sized portion. Start light and use fur strokes. Do stripes and shading as you go. Each coat adds a darker color. (See C.)

4. Add a little black to your watery sepia and continue with the dark areas such as the stripes and shadows. Add repeated coats to the inside of the lower kitten's mouth until it looks correct. Going slowly makes a work more consistent. (See D.)

5. With the same paint, darken the stripes, mouth, eyes, shadows, and any other areas that need a final accent. (See E.)

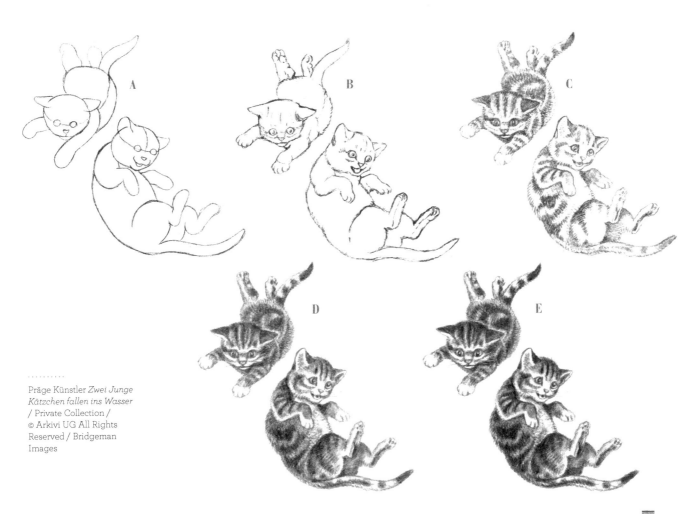

Präge Künstler *Zwei Junge Kätzchen fallen ins Wasser* / Private Collection / © Arkivi UG All Rights Reserved / Bridgeman Images

C

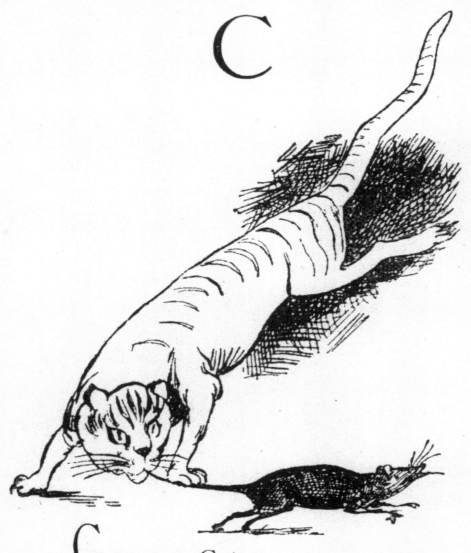

C was a Cat
Who ran after a Rat,
But his courage did fail
When she seized on his tail.

c !

Crafty old Cat!

HUNTING

We think of Edward Lear as the writer of children's nonsense poems, like "The Owl and the Pussycat." But he was also a highly skilled artist, known for his travel painting. The drawings that he did for his limericks and poems look simple but are skillful character studies.

1. Match Lear's quick sketch style with long sweeping lines. The cat's expression is important. (See A.)

2. Lightly add stripes and refine the outline and little linear accents that explain the anatomical structure with brevity. (See B.)

3. Ink boldly over everything. Make the rat and the shadow dark and bold. (See C.)

4. Thicken the lines that need emphasis. Add some shadow and a little color on the rat. (See D.)

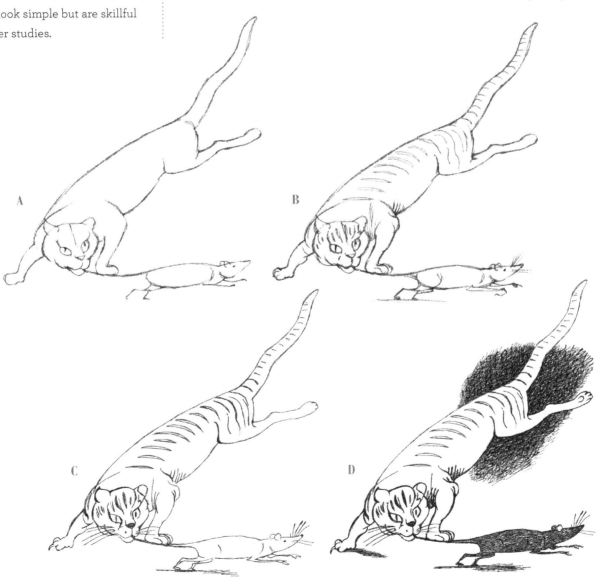

A

B

C

D

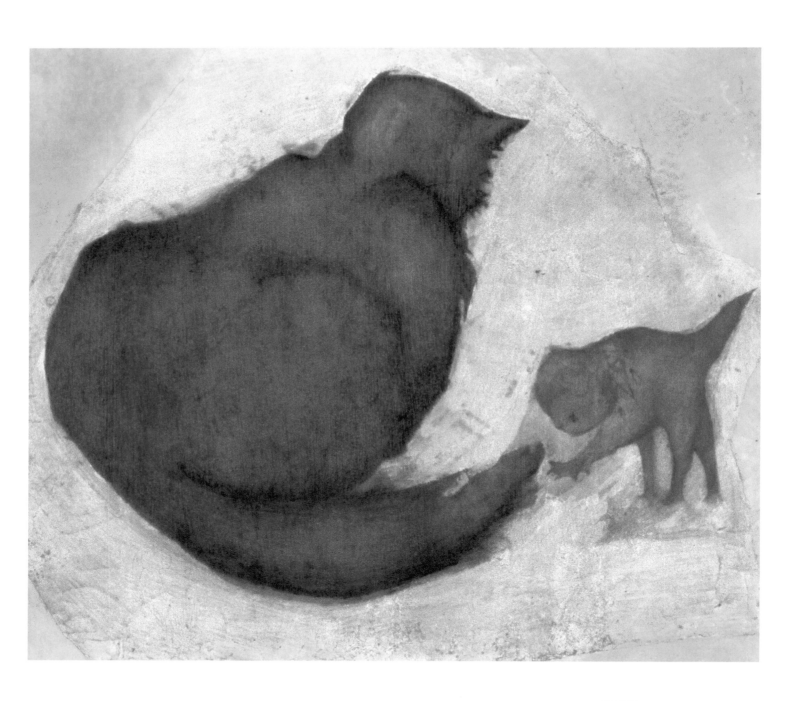

Cat and Kitten, watercolor on plaster, Edward Coley Burne-Jones, English, 1833–1898/ © Mallett Gallery, London, UK / Bridgeman Images

PLAYING

Edward Burne-Jones painted this delightful image on the wall to cheer his young daughter when her nanny sent her to the corner for punishment. I think it must have worked; I find its charm irresistible.

1. The mother cat is foreshortened, so stack her component forms. The kitten is all head. (See A.)

2. I changed the sketch to a somewhat angular outline for the kitten and its mother. The simplicity is part of the charm. (See B.)

3. Pencil lines stroked in the same direction build a texture that gives interest to the solid shapes. I used black shading on mama cat and red-brown on the kitten. (See C.)

4. A light, flat, watercolor wash of red-brown for mama and yellow ochre for the kitten allow the pencil texture to show through. (See D.)

5. Darken the cats with more coats of color. Soften the yellow kitten with a brown wash. (See E.)

6. Using opaque watercolor, paint the eye, nose, and mouth of the kitten over the last darkening washes. These details are tiny but so expressive. (See F.)

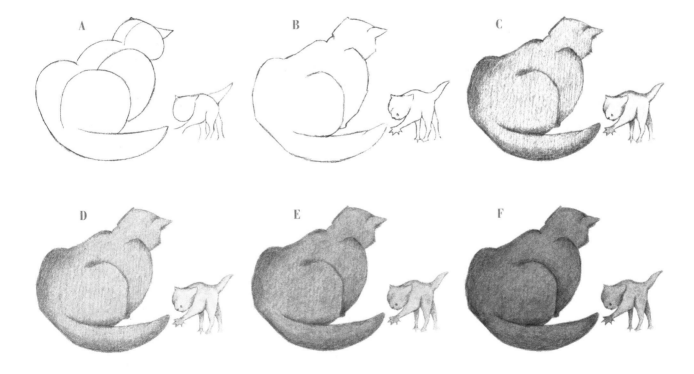

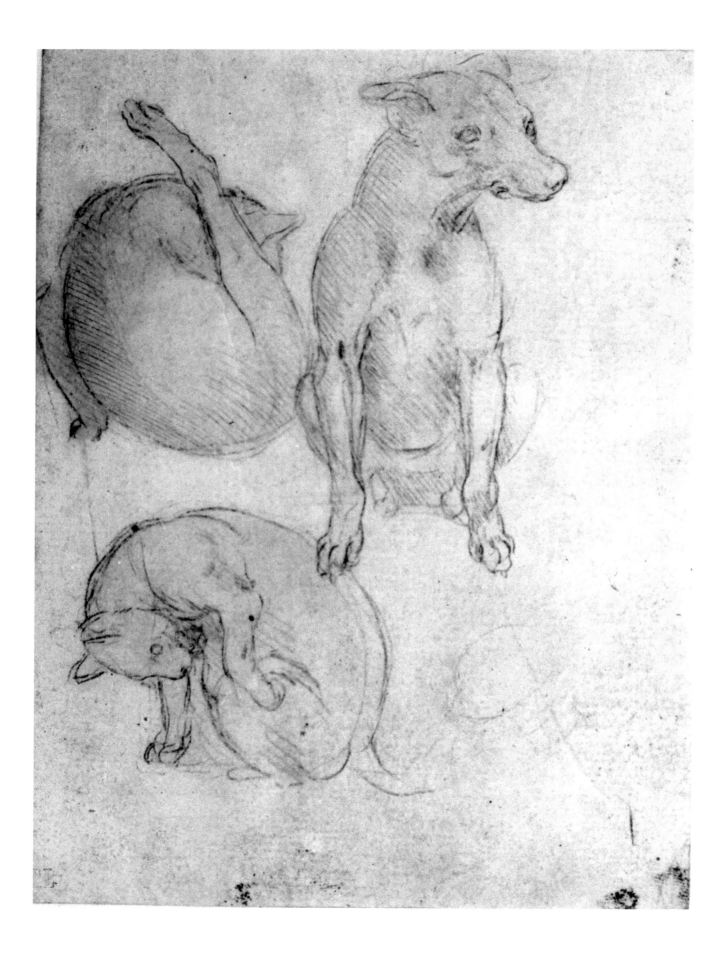

PREENING

Copying Leonardo da Vinci's drawings has been an art school assignment for hundreds of years, so welcome to the tradition. The cats drawn here are as natural and intimate as a snapshot. Anyone who has ever watched a cat will recognize both poses.

1. Use graceful, sweeping lines to draw the cat shapes. These cats are beautiful at every stage. (See A.)
2. Shade as Leonardo did. For fun, add his exploratory lines as well as the ones he emphasized. (See B.)
3. Darken the shading. Leonardo was left handed and his natural pencil stroke was from the upper left of the page toward the lower right. (See C.)
4. Add the last accents of darkened lines and shading, and you have two handsome Leonardo da Vinci cats. (See D.)

Study of a Dog and a Cat, c. 1480, metalpoint on paper, Leonardo da Vinci, Italian, 1452–1519 / British Museum, London, UK / Bridgeman Images

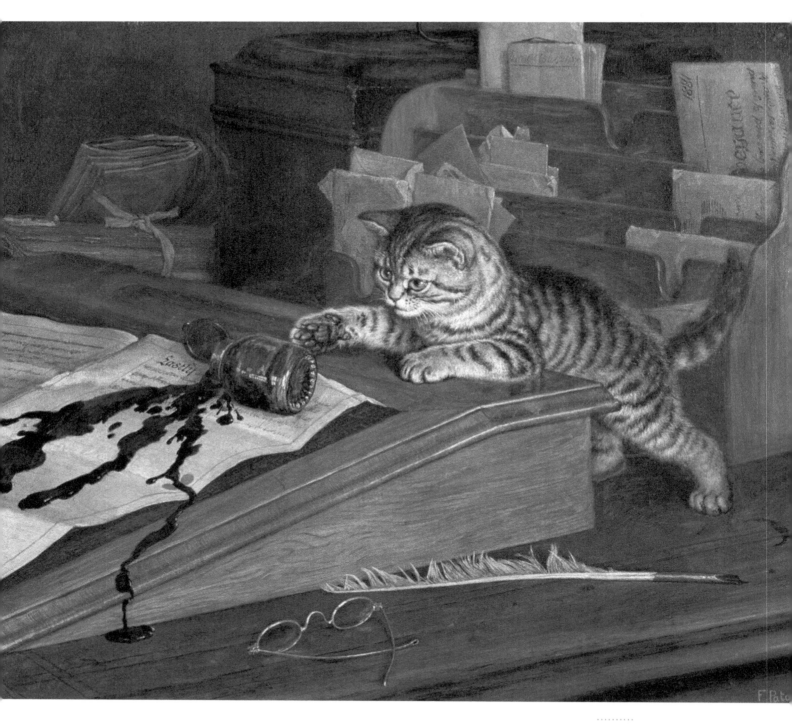

KITTENS 1

You can tell this is an older kitten because its body is bigger in proportion to its head, which is still quite large with low-set eyes. Its paws have grown faster than its legs and the tail is still much shorter than that of an adult cat. It is also up to some very kitten-like mischief.

1. Use pencil to draw the basic forms within the cat. (See A.)
2. With pencil, add stripes and features to the face. Note the mischievous smile. (See B.)
3. Add details in brown and black pencil. Paint brush strokes in the direction of the fur track to render the stripes. Also paint the eyes, nose, and muzzle. (See C.)
4. Using a small brush, paint fur strokes of ochre, burnt umber, and light brown all over the kitten. When the small strokes are dry, wash a yellow brown over the whole body. (See D.)
5. More fur strokes and washes of slightly darker colors will build up a rich coat color. (See E.)
6. Finish with black on the stripes, around the pads, in the shadows, and along the back. (See F.)

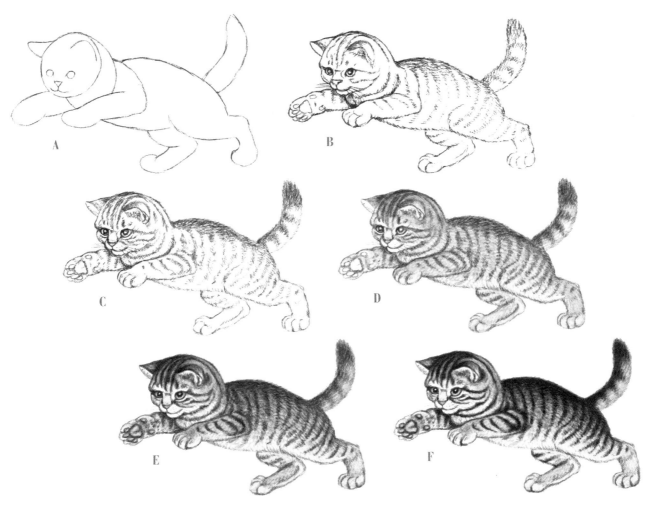

A

B

C

D

E

F

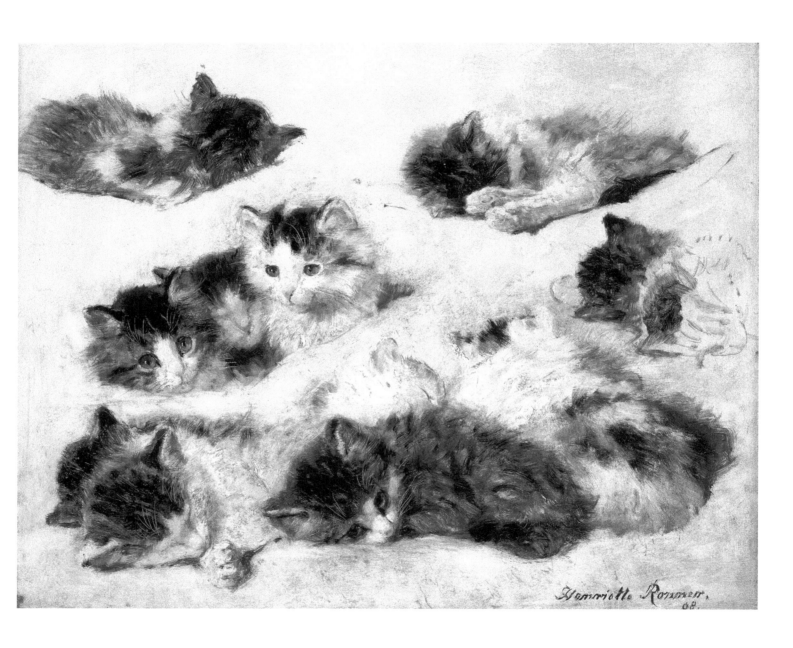

KITTENS 2

These lovely kittens are wonderful subjects, and the style of painting suits them. I picked out three kittens to work on, but any of them would be good choices.

1. Sketch the three little kittens in outline. Use sketchy line for the soft fur. (See A.)
2. Using colored pencil, lay in the reddish-brown fur. The noses are very small and pink. The muzzle is tiny and the big blue-green eyes with a hint of yellow-ochre are wide, except, of course, for the snoozing kitten. (See B.)
3. Paint the fur using a little pale yellow and gray for the white fur and two or three browns for the color patches. Little strokes at the edges of the patches will keep the fur soft in appearance. (See C.)
4. Time to use black and dark brown, but build up slowly. The central kitten is in shadow, so lightly color his white fur with pale yellow and neutral tint. (See D.)
5. As final touches, tone down the red-brown fur and add shadows on the white fur. Black accents are always added last. (See E.)

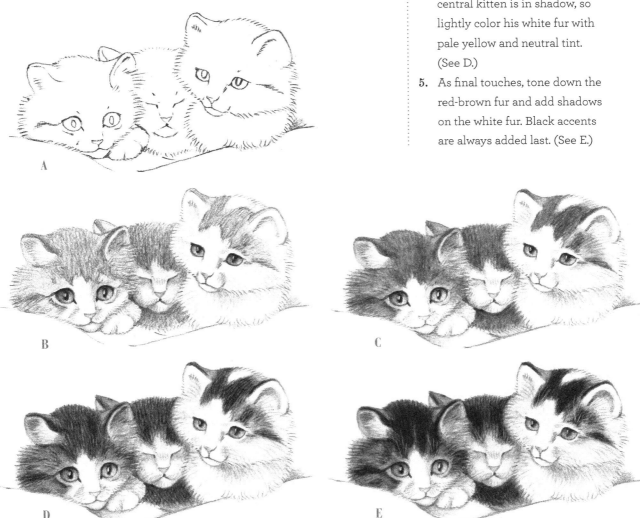

A

B

C

D

E

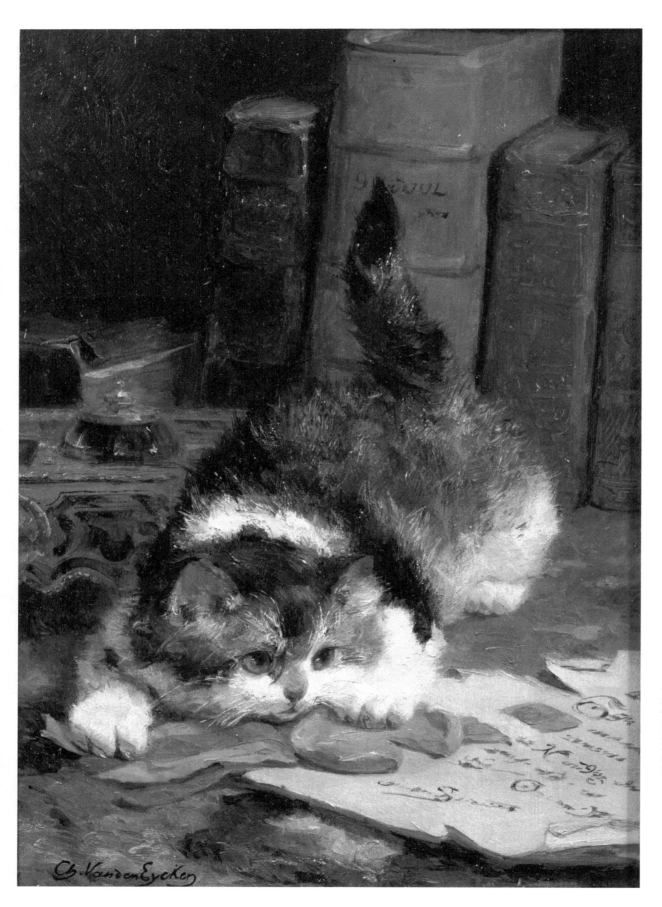

KITTENS 3

This foreshortened, fluffy kitten with a mottled coat presents several drawing challenges. We'll tackle each as the drawing progresses.

1. Foreshortening is difficult because the mind tells us that what we see cannot be true. A cat's body is not the same length as the width of its head, yet foreshortened bodies appear that way. Trust your eyes. The stacked shape method works because it overrides what we know. Sketch the head shape in front of the oval body shape. (See A.)

2. Because the cat is fluffy, do not draw solid edges. Make lines that stick out from the body to build up the soft shape. Add the details of the face. (See B.)

3. In the white fur areas, use a small brush to create volume with pale colors. Paint your color strokes as you draw the sketch. Paint the eyes and nose. (See C.)

4. Use lots of darker colors painted with little strokes to produce a mottled look. Put red brown paint in the areas that will be black. (See D.)

5. Add the black spots slowly, making sure that there are no crisp edges. (See E.)

6. Finish with black and a little neutral tint to keep the splotchy look of the fur. (See F.)

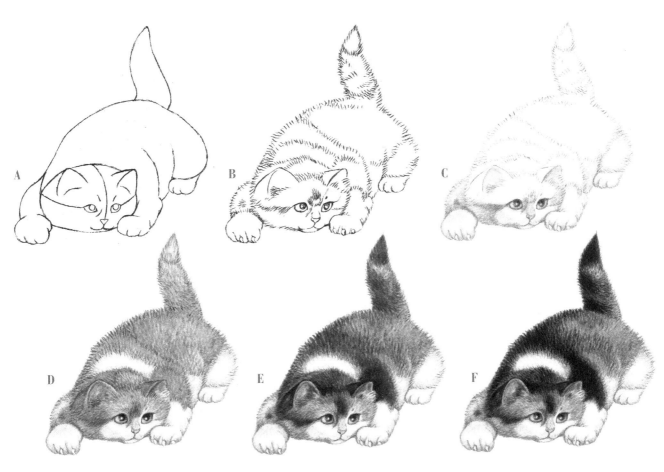

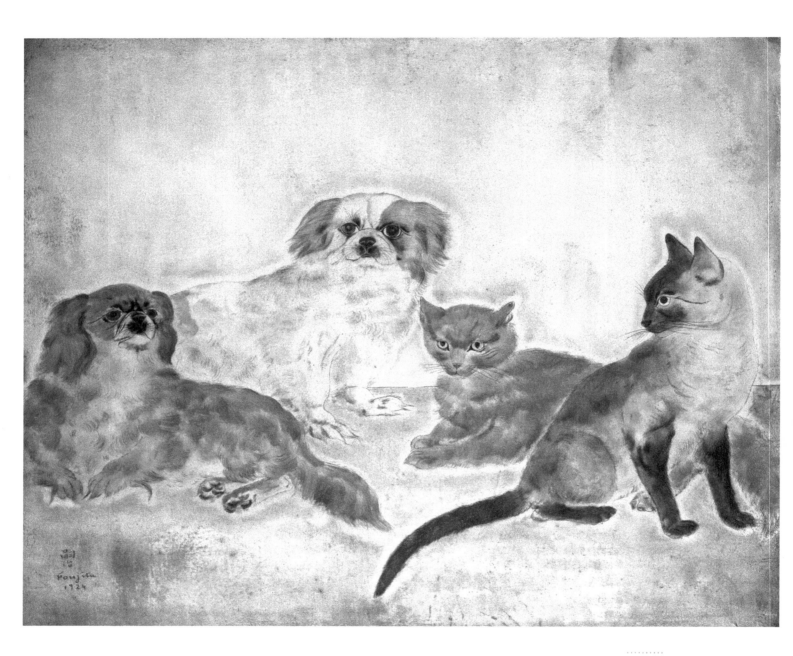

Cats and Dogs, 1924,
Foujita, Tsugouharu
Leonard (1886–1968)
/ Private Collection /
Bridgeman Images

POINTS

Points are the dark fur extremities of a cat often seen in eastern breeds such as Siamese. They may include the nose, ears, tail, and paws. Colors run from black to lavender.

1. Do a refined pencil sketch of the outline and form. It will not be erased, so you can go dark. (See A.)
2. Try out coat colors with pencil. Confident watercolor artists can skip this step. (See B.)
3. Still using pencil, darken the points. Enrich the coat color as needed. (See C.)
4. Finish with watercolor over the colored pencil. Notice how the black lines show through. (See D.)

This is an ink sketch of Mushkila, a friend's mixed breed lavender-point cat found abandoned in Central Park. She lived a long, cherished life and had all seven points.

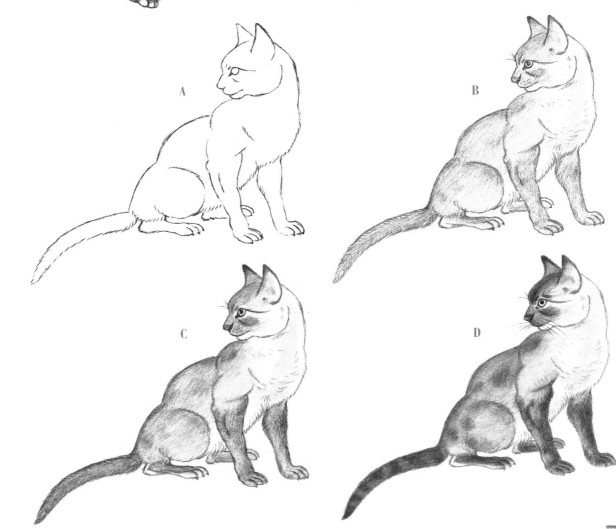

A

B

C

D

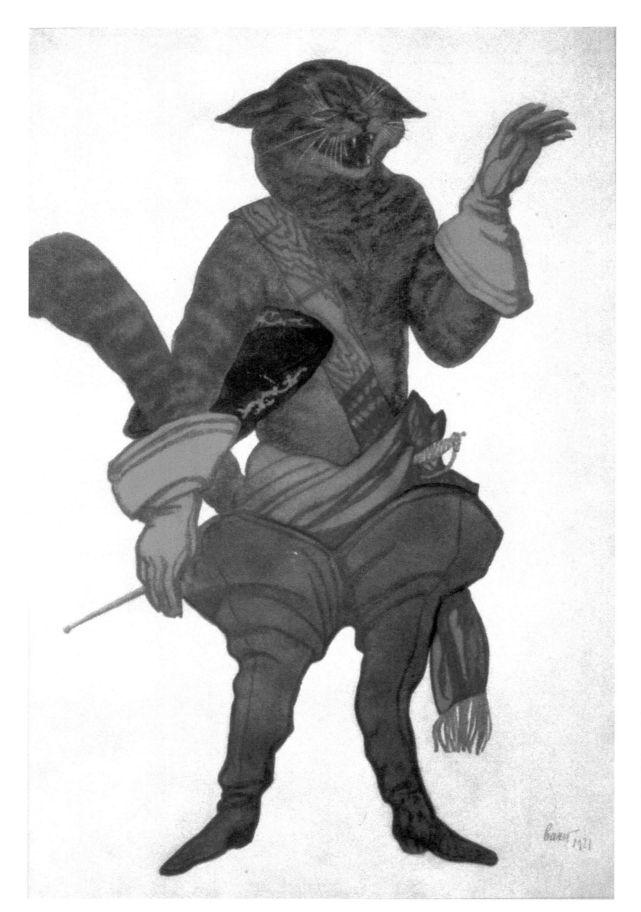

Puss in Boots, from
Sleeping Beauty,
1921, color lithograph,
Léon Bakst, Russian,
1866–1924 / Private
Collection / The
Stapleton Collection /
Bridgeman Images

THE CAT AS DESIGN

Léon Bakst designed this flamboyant Puss in Boots costume for Sergei Diaghilev's revival of the ballet *Sleeping Beauty*. In Bakst's version, Puss is an elegantly dressed, dashing feline of the world.

1. Draw an outline of Puss in his finery. Use a light line so you can easily erase it. (See A.)
2. Ink the sketch and add fur, the sash, and shadows. (See B.)
3. Use gray paint on a small brush to paint Puss's stripes. (See C.)
4. Paint brown over the fur and gold on the sword. (See D.)
5. Paint the sash and gloves red. (See E.)
6. Wash brown paint over the boots. Using a neutral tint, add shadows on the boots. Burnt umber will shade the gloves. (See F.)

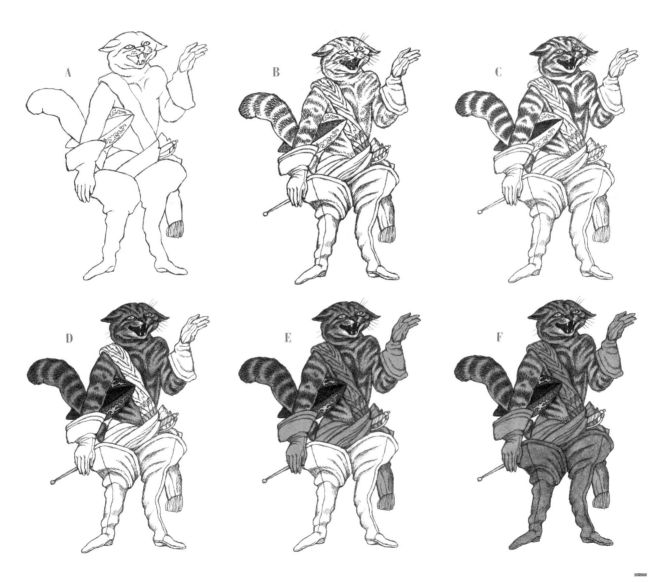

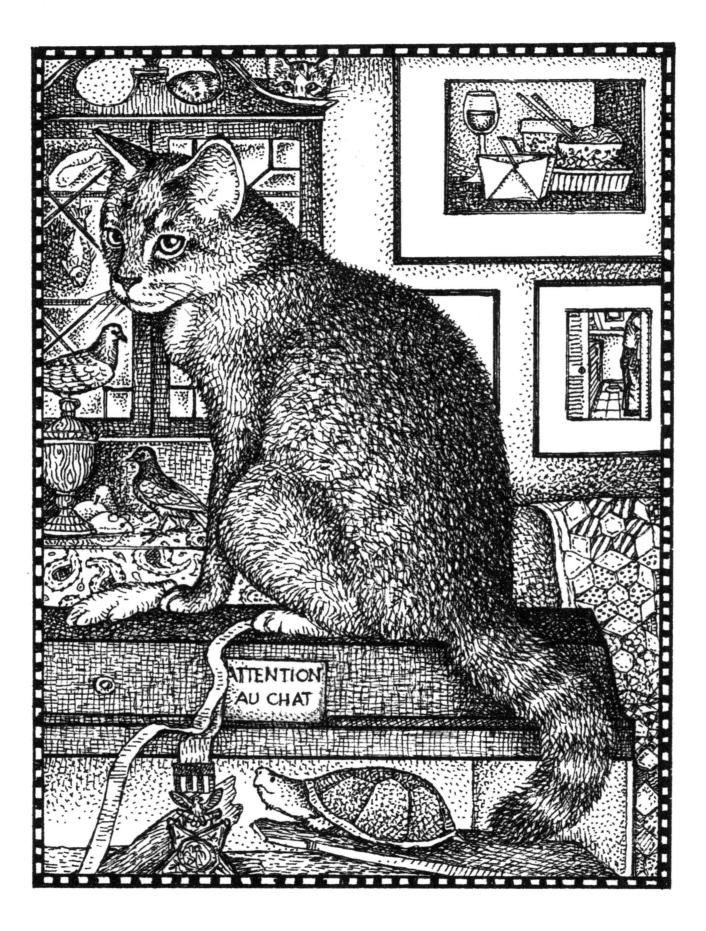

THE CAT'S PORTRAIT

Ella was an ASPCA adoptee. Tough and unruly, she had been turned back in once already. When we brought her home, she broke every rule we tried to set. She had a sweet, soulful little face and a wicked little devil's heart. When she died, I wanted to do her portrait with symbols of her life. Mostly I needed to capture her impish face.

1. I sketched her with her back toward the viewer and a coy turn of the head. (See A.)
2. Her shape is inked with a broken outline, as she was a fuzzy shorthair. I could not wait to try her face. (See B.)
3. Ella was mousy-gray with white paws. She had absolutely no distinctive markings. I inked short fur all over her shape and worked on her smile. (See C.)
4. Keeping her fuzzy, I added shading. (See D.)
5. Messy, little uneven stripes were visible on her coat in some lighting. (See E.)
6. Final shading and dashed lines to mess up her fur are added, and she is finished. Meet Ella. (See F.)

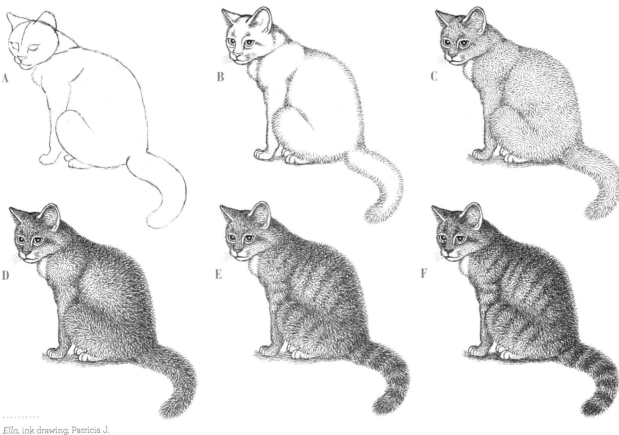

Ella, ink drawing, Patricia J. Wynne, 1992 / Collection of the artist / patriciawynne.com

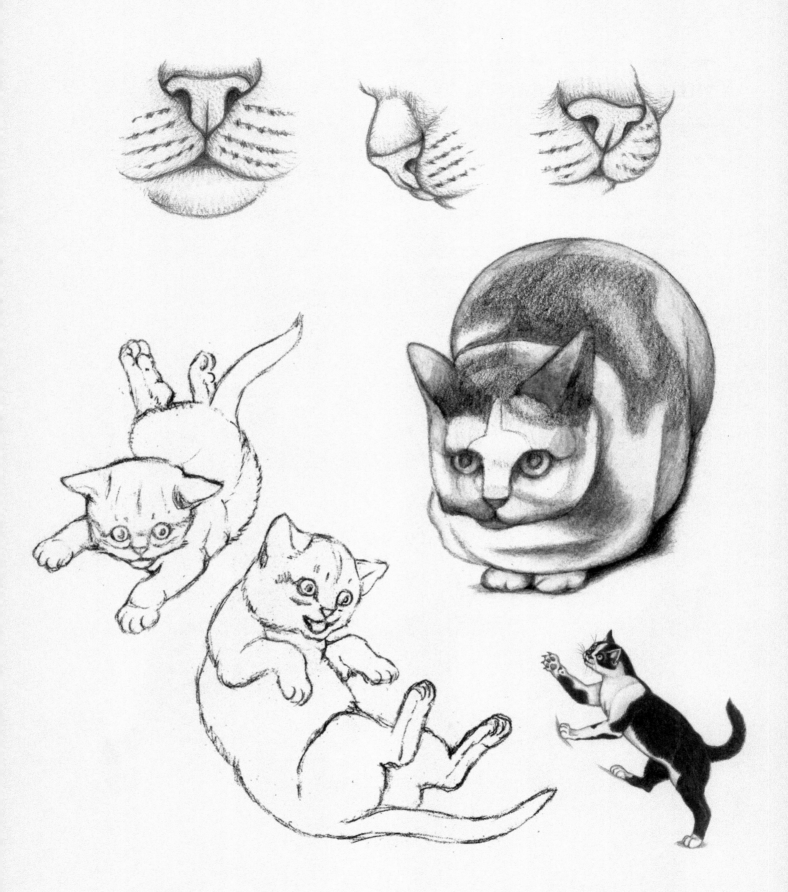

ABOUT THE ARTIST

ARTIST, ILLUSTRATOR, and teacher Patricia J. Wynne grew up surrounded by farms where Chicago's nightglow meets the Illinois prairie. She has drawn animals her whole life. After studying printmaking with Mauricio Lasansky at the University of Iowa, meeting her husband, artist Maceo Mitchell, and embarking on a gallery career, Wynne moved to Detroit, where she taught drawing at Wayne State University. She also taught printmaking at the University of Windsor, Ontario, Canada. A position as scientific illustrator at the University of Michigan followed and with it an entirely new avenue for drawing animals opened. Since that moment, the study of animals became a daily discovery process and her drawings and prints were flooded with revelations about animals of all kinds. It was full steam ahead with a move to New York City and a diverse freelance career. Drawing animals for scientists and illustrations for *Scientific American*, the *New York Times*, and the *Wall Street Journal*; drawing characters for *Star Wars*; producing more than 200 books for adults and children; teaching animal drawing at the Central Park Zoo, American Museum of Natural History, Maritime Aquarium at Norwalk, and New York Botanical Garden; as well as participating in gallery shows, juried exhibitions, and workshops have kept Wynne very busy. These days she spends more time than ever making prints.

Patricia Wynne lives and draws today in New York City across from Central Park with her husband, Maceo, two cats, six lizards, three turtles, four canaries, and 100 fish.

Brimming with creative inspiration, how-to projects, and useful information to enrich your everyday life, Quarto Knows is a favorite destination for those pursuing their interests and passions. Visit our site and dig deeper with our books into your area of interest: Quarto Creates, Quarto Cooks, Quarto Homes, Quarto Lives, Quarto Drives, Quarto Explores, Quarto Gifts, or Quarto Kids.

© 2017 Quarto Publishing Group USA Inc.
Text and Illustrations © 2017 Patricia J. Wynne

First Published in 2017 by Rockport Publishers, an imprint of The Quarto Group,
100 Cummings Center, Suite 265-D, Beverly, MA 01915, USA.
T (978) 282-9590 F (978) 283-2742 QuartoKnows.com

Rockport Publishers titles are also available at discount for retail, wholesale, promotional, and bulk purchase. For details, contact the Special Sales Manager by email at specialsales@quarto.com or by mail at The Quarto Group, Attn: Special Sales Manager, 100 Cummings Center, Suite 265 - D, Beverly, MA 01915, USA.

ISBN: 978-1-63159-294-2

Library of Congress Cataloging-in-Publication Data

Wynne, Patricia, author.
Cats : secrets of observational drawing / Patricia J. Wynne.
Series: Classic sketchbook
ISBN 9781631592942 (paperback)
1. Cats in art. 2. Drawing--Technique.
 NC783.8.C36 W96 2017
743.6/29752--dc23
2017005835

Cover Images: Patricia J. Wynne and Bridgeman Images
Design and Page Layout: Stacy Wakefield Forte

Page 104: *Cats and Dogs* by Tsugouharu Leonard Foujita
© 2017 Artists Rights Society (ARS), New York/ADAGP, Paris

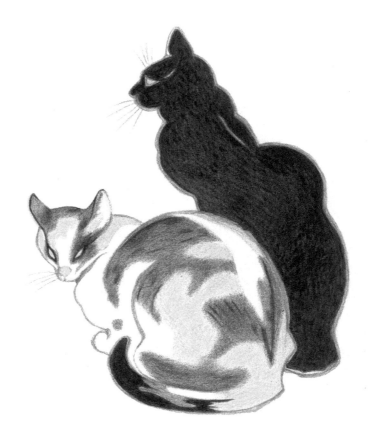